KABUKI

繪本歌舞伎十八番

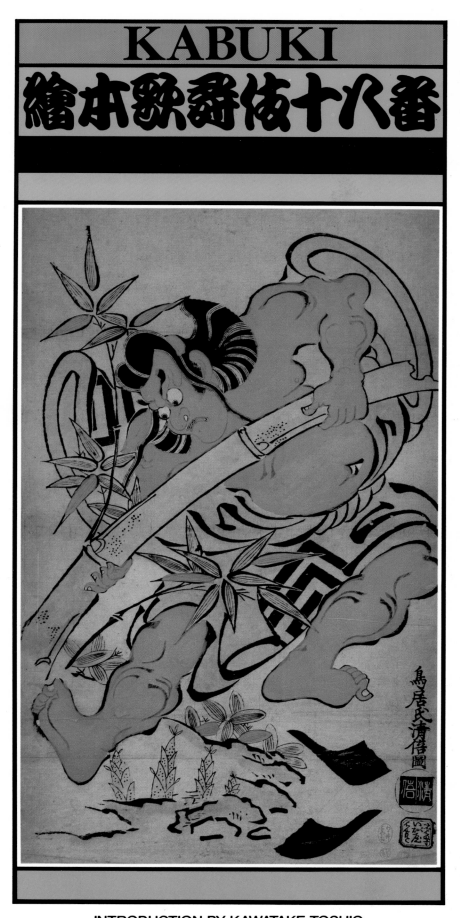

INTRODUCTION BY KAWATAKE TOSHIO
PHOTOGRAPHY BY IWATA AKIRA
TRANSLATION BY HELEN V. KAY

CHRONICLE BOOKS

First published in the United States 1985 by Chronicle Books

Copyright ©1984 by Libroport Co., Ltd. All rights reserved. No part of this book may be reproduced in any form without written permission from the publisher.
First published in Japan by Libroport Co., Ltd.
Printed in Japan by Dai Nippon Printing Co., Ltd., Tokyo

Library of Congress Cataloging in Publication Data

Ehon kabuki jūhachiban. English.
 Kabuki.

Translation of: Ehon kabuki jūhachiban.
1. Kabuki. 2. Kabuki plays. I. Kawatake, Toshio, 1924–
II. Iwata, Akira.
PN2924.5.K3E3713 1985 792'.0952 85-11701
ISBN 0-87701-366-7 (pbk.)

10 9 8 7 6 5 4 3 2 1

Chronicle Books
One Hallidie Plaza
San Francisco, CA 94102

Contents

"Kabuki Jūhachiban" and Danjūrō

by Kawatake Toshio

In Japan when somebody sings or does a trick at a party, people will comment that it is his "jūhachiban" (his forte). This expression originated in the "Kabuki Jūhachiban" (Kabuki Eighteen). There are other expressions like "nimaime" (a young beau), "sanmaime" (a comic), "sutezerifu" (a parting shot) and "mie o kiru" (to pose) which are used in daily conversation and the Kabuki.

Although Kabuki is closely connected with the life of the common people of Edo (Tokyo) it does not mean that the "Kabuki Eighteen" collection includes only eighteen masterpieces. For example, "Chūshingura" (The Treasury of 47 Loyal Retainers), "Terakoya" (Village School, an act from a play called "Sugawaradenju Tenaraikagami"), "Yotsuya Kaidan" (The Ghosts at Yotsuya) and "Shiranami Gonin Otoko" (an act from a play called "Benten Kozō") are wellknown dramas even in foreign countries but they are not included in the collection.

The "Kabuki Eighteen" in order of popularity are:

"Kanjinchō", "Sukeroku", "Narukami", "Shibaraku", "Ya-No-Ne", "Kenuki", "Oshimodoshi", "Fudō", "Uirōuri", "Zōhiki", "Kagekiyo", "Fuwa", "Uwanari", "Kan-U", "Kamahige", "Nanatsumen", "Gedatsu" and "Jayanagi".

The plays in the first half of the list are often performed but the latter half are known to people only by their titles.

This collection was compiled by the leading actor of Edo, Ichikawa Danjūrō VII when in 1832 the fourth performance of "Sukeroku" at the Ichimura-za in Edo was for the first time called "One of the Eighteen Festive Dramas of Ichikawa Ebizō". However, it is believed that even before this date there existed a similar collection of the "Kabuki Eighteen" although its content is unknown. The name originated either in "Amida no Jūhachigan" or "Bugei Jūhappan" and the number eighteen has its origin in Buddhism. From expressions like "oni mo jūhachi" (sweet sixteen) and "jūhachi daitsū" (men of the world) it is obvious that the number eighteen has long been popular in Japan as well as being considered a lucky number.

In 1837 when Danjūrō VII performed "Uwanari" under the title of "Hana no Kumo Kane ni Iru Tsuki", "One of the Kabuki Eighteen" was written in small characters above the title. However, it was in 1840 during the first performance of "Kanjinchō" at the Kawarazaki-za which was dedicated to the 190th birthday anniversary of Ichikawa Danjūrō I that the public was officially informed about the "Kabuki Eighteen" (Denrai Soro Kabuki Jūhachibannouchi). 1840 has been officially accepted as the year in which the "Kabuki Eighteen" was established.

In this way the eighteen plays of the Ichikawa Danjūrō's family art (o-ie-gei) have become the "Kabuki Eighteen". It also shows how famous, popular and important the name Danjūrō was in Edo Kabuki.

The present Ebizō will succeed to the title of Danjūrō XII in spring 1985. The ancestors of the Ichikawa family are said to have been of warrior class in Kōshū but Danjūrō I was born in Edo. The audience was pleasantly surprised and impressed when at the age of fourteen Danjūrō I made his stage debut in the role of Sakata Kintoki ("Shitennō Osanadachi") at the Nakamura-za in 1673. His colorful black and red facial makeup, padded costume and obi and the enormous ax with which he fought his enemies, all became the trademark of the "ara-goto" style of acting which is the foundation of the "Kabuki Eighteen".

Behind the popularity of this performance was the folk belief which held that the hero is encouraged by a divine power which drives away evil spirits and helps an ordinary man to achieve superhuman feats. Even to this day during the announcement of a new name or on any other festive occasion, the "nirami" form takes place. With: "Kichirei ni yori hitotsu nirande goran ni iremasu" the arms are flung sideways, palms outward and fingers crooked, the right leg is bent under the body and the left leg is thrown out and strongly stamped on the ground at which point the famous glare can be seen. Danjūrō I became a famous actor of the Genroku Period through the "ara-goto" and it is also obvious that he deeply believed in the god Fudō (Acala) which is enshrined at Narita Temple because he has made his "yagō" (stage name) the "Naritaya". It is possible that the "Kabuki Eighteen" nucleus, the "religion" reflects the minds of the common people.

Danjūrō II was a very handsome actor who in addition to the "ara-goto" style of acting, possessed the technique and talent for the softer, more romantic style of Kamigata (Kyoto-Osaka) "wa-goto" which he displayed in the role of Sukeroku still being performed his way. He was an even more popular actor than his illustrious father. Danjūrō III died very young but Danjūrō IV was another actor who made the Ichikawa family famous. In addition to carrying on the hereditary style of acting of the family he also originated the style in which the role of Matsuōmaru of the "Sugawaradenju Tenaraikagami" and Kumagai Naozane of the "Ichinotani Futabagunki", plays which were originally written for the puppet theater, are still being performed. His beloved grandson died when he was eight years old and it was on the last day of his performance of the "Terakoya" ("Sugawaradenju Tenaraikagami") in which Matsuōmaru's young son is killed that Danjūrō went back to his dressing room after the performance, shaved his head and left the theater to live in seclusion in Kiba.

Danjūrō V performed not only the "Kabuki Eighteen" but also appeared in "onnagata" (female impersonator) roles. He also played the role of Yuranosuke ("Kanadehon Chūshingura") for the first time. Danjūrō VI died at the age of twenty two.

Danjūrō VII who assumed his new name at the age of ten became one of the most illustrious of the Ichikawa family actors. He is famous for his realistic portrayal of Iemon ("Yotsuya Kaidan"), credited with the establishment of the "Kabuki Eighteen", and creation of "Kanjinchō" which he adapted faithfully from a Nō play called "Ataka". His extravagant life style led to his banishment from Edo but he continued to flourish in the Kansai area.

Danjūrō VII's oldest son, Danjūrō VIII killed himself at the age of thirty two.

Danjūrō VII's fifth son, Danjūrō IX was adopted by the manager of the Kawarazaki-za and participated in the Meiji theater reform. He did not have any sons so he adopted Ichikawa Sanshō who was posthumously awarded the name of Danjūrō X for his contribution to the Kabuki with his revivals of the lesser known numbers of the "Kabuki Eighteen".

Danjūrō I wrote the original seven of the "Kabuki Eighteen", Danjūrō II eight and Danjūrō IV three but when Danjūrō VII established the collection he had the manuscripts of "Narukami", "Shibaraku", "Sukeroku", "Ya-No-Ne", "Kenuki", "Fudō", "Uirōuri" and "Oshimodoshi", with the rest recorded in literature. Danjūrō VII wrote "Kanjinchō" but it was after the Meiji Period that Ichikawa Sadanji II, Danshirō I and more particularly, Ichikawa Sanshō (Danjūrō X) made the important revision work.

Danjūrō XI, affectionately called "Ebisama" but known as Ebizō since 1940, was a gifted, handsome actor. He died at the age of fifty six in 1965 only three and half years after he became Danjūrō XI. His son, the present Ebizō will be Danjūrō XII. In this way the "Kabuki Eighteen" and the name Danjūrō will continue.

As mentioned above, the "ara-goto" (exaggerated makeup, costumes and gestures) style is the trademark of the "Kabuki Eighteen" collection. The thick red and blue lines of "kumadori" (makeup) which represent strength, goodness and evil; the fierceness of the "kurumabin" wig; the three enormous "ōdachi" swords which make the hero look much larger; the force of the recurved toes and fingers; the famous cross-eyed glare—"nirami"; the elaborate and varied style of "mie" (a pose); the soronous "tsurane" (the self-introduction speech). the dazzling colors, the visual feast in lively motion and the free spirits are not found in any other art. Kabuki's stylized beauty is completely different from the Western or modern theater which emphasizes realism.

Moreover, all heroes of the "Kabuki Eighteen" plays are human beings, excepting "Fudō". As said before, the "ara-goto" style is also named the "aragami-goto" (fierce deity) and "arahitogami-goto" (diety appearing in human form) which acts out superhuman feats. Still, the main characters are unmistakenly human although possessing superhuman strength, they are neither gods nor devils. The heroes of "Sukeroku", "Shibaraku" and "Kanjinchō" are humans, so is Narukami in the "Narukami"—a priest who is seduced by a beautiful woman. In "Oshimodoshi", the righteous warrior pushes the evil spirit back to the stage.

Released from the religious spell of the middle ages and the feudalistic oppression, the common people of Edo glorified the humans. The gorgeousness of the costumes and makeup, the universal sentiment and human passions as well as the aesthetic sense helped to create the "Kabuki Eighteen". Does Kabuki evoke memories of the basis of life to the modern age people who are too preoccupied with logic and machine civilization?

The "Kabuki Eighteen" displayed the endless opportunities and possibilities available to human beings, long before the ultramodern mode of life showed it. And the actors of the successive generations of Ichikawa Danjūrō are undoubtedly the guardian angels of the "Kabuki Eighteen".

1

御存知歌舞伎十八番
18 BEST KABUKI PLAYS

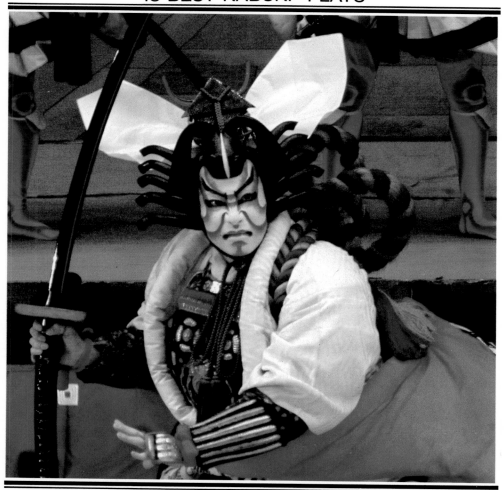

**SUKEROKU / KANJINCHŌ / KENUKI / NARUKAMI / SHIBARAKU
KAGEKIYO / UIRŌURI / OSHIMODOSHI / NANATSUMEN
FUDŌ / FUWA / ZŌHIKI / YA-NO-NE / KAMAHIGE
GEDATSU / KAN-U / IAYANAGI / UWANARI**

SUKEROKU

SUKEROKU (Sukeroku)

The full title of this one act play is called "Sukeroku Yukari no Edozakura". It was the first to be included in the "Kabuki Eighteen" in 1832 by Ichikawa Danjūrō VII.

Agemaki, the most beautiful and famous courtesan of Yoshiwara, a red-light district in Edo; Sukeroku or Soga Gorō, a chivalrous commoner and Agemaki's lover, who looks very handsome in his black kimono, "muki-mikuma" makeup, and a purple headband; and Ikyū, an enormously rich man who tries to win Agemaki's favor, are the main characters of this enjoyable play. Sukeroku is frequenting licensed quarters and picks quarrels to find his sword Tomokirimaru which has been stolen from him. Sukeroku insults Ikyū particularly offering him a pipe holding it between his toes and even taking off his footwear and putting it on Ikyū's head, all to make him draw his sword. Ikyū stoically bears it but later, when he tries to trick Sukeroku into making treasonable anti-Shogunate statements he gets caught in his own trap when he draws his sword to slice an incense burner. Sukeroku immediately recognizes his sword but Ikyū hastily departs. Sukeroku waits for him to claim his sword and in the end kills both Ikyū and his retainer. When he is about to be caught by the authorities, Sukeroku hides in a barrel full of water and later Agemaki comes to help him to escape.

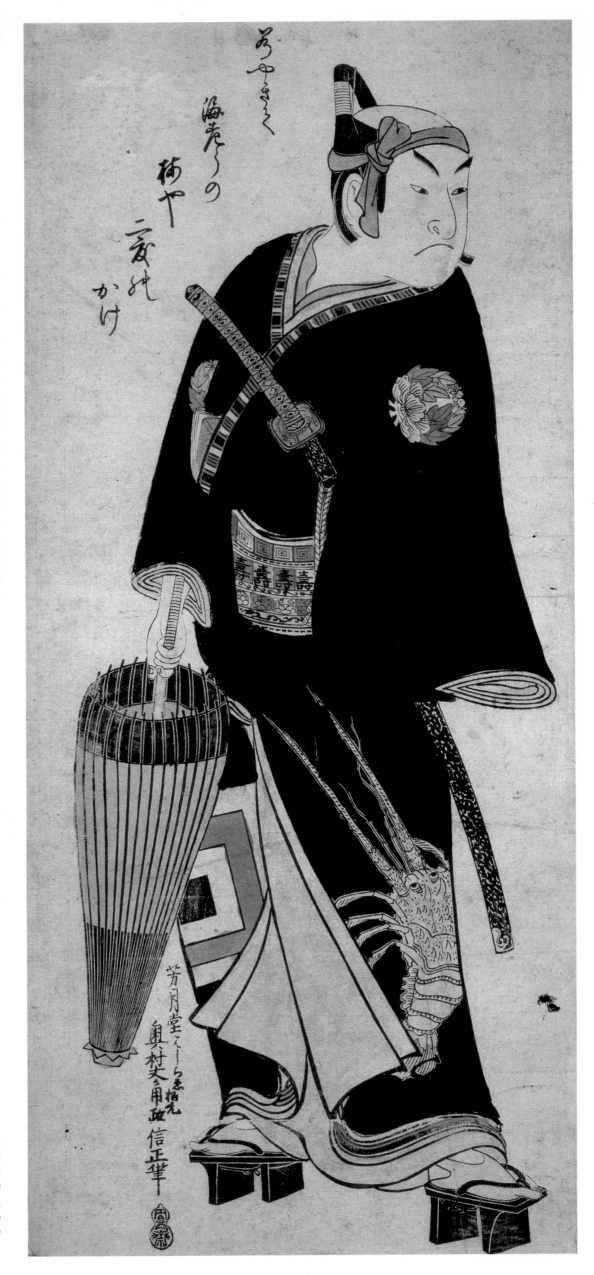

By Okumura Masanobu. Danjūrō II as Hanagawado Sukeroku at the Nakamura-za in March 1749. Danjūrō I performed this role in bravado style, but Danjūrō II used the softer, more amorous approach of the Kyoto-Osaka style of acting (wa-goto). It is said that the appearance of Gyōu, a card player and man about town from Kuramae who made nocturnal visits to Yoshiwara, served as an example for Sukeroku. (Tokyo National Museum)

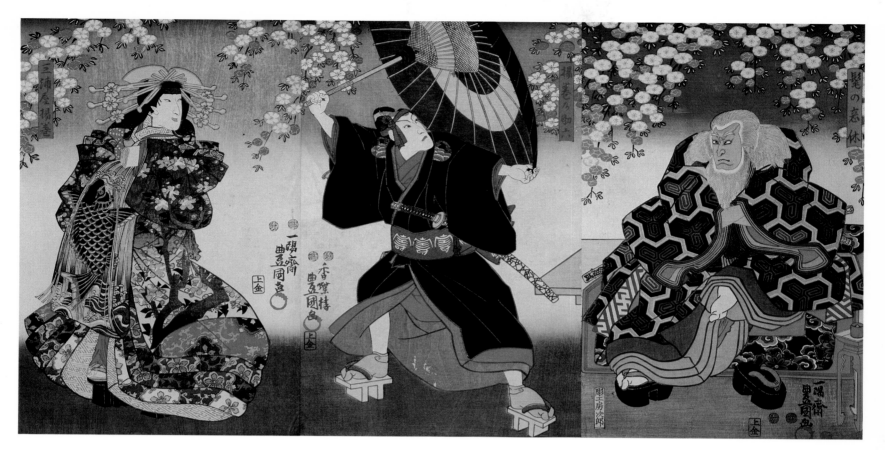

By Utagawa Toyokuni III. Bandō Shūka as Miuraya Agemaki, Danjūrō VIII as Agemaki No Sukeroku and Ichikawa Kodanji IV as Hige No Ikyū at the Nakamura-za in March 1850. On this occasion, Sukeroku was presented with an umbrella and tobacco pipes and Agemaki with the long-handled umbrella and the paper lantern that she uses when visiting her customers. These gifts came from Yoshiwara. From the Uogashi fish market, Sukeroku received the headband and wooden clogs. The presents were always addressed to Sukeroku and Agemaki, not to the actors performing the roles. Because it is set in Yoshiwara during the cherry blossom season, this play is traditionally staged in March or April. (Waseda University Theater Museum)

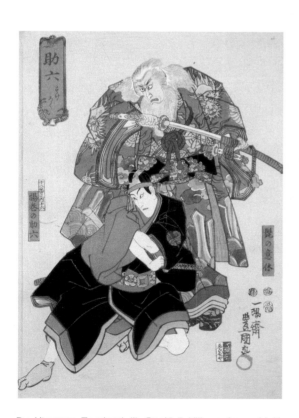

By Utagawa Toyokuni III. Danjūrō VIII as Agemaki No Sukeroku and Danjūrō VIi as Hige No Ikyū. The headband is usually tied on the left side and suggests that the wearer is ill. Sukeroku's is more a touch of fashion. He is, after all, the most handsome man in Edo. (The National Diet Library)

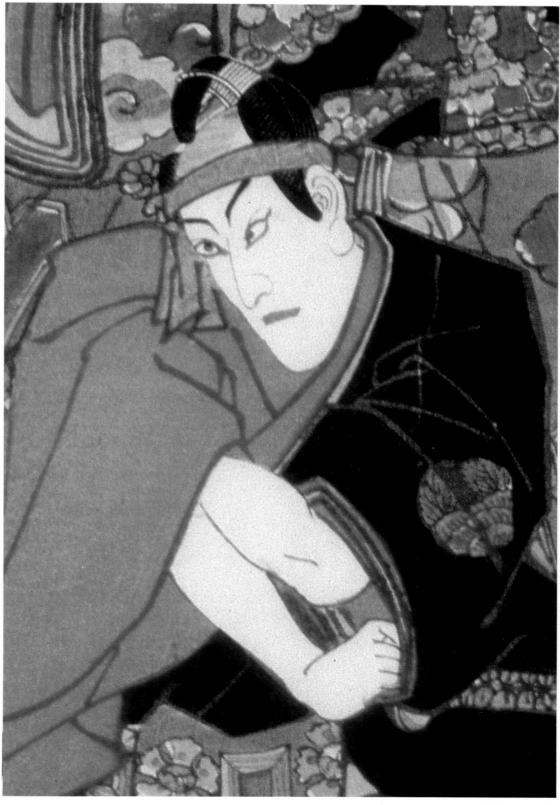

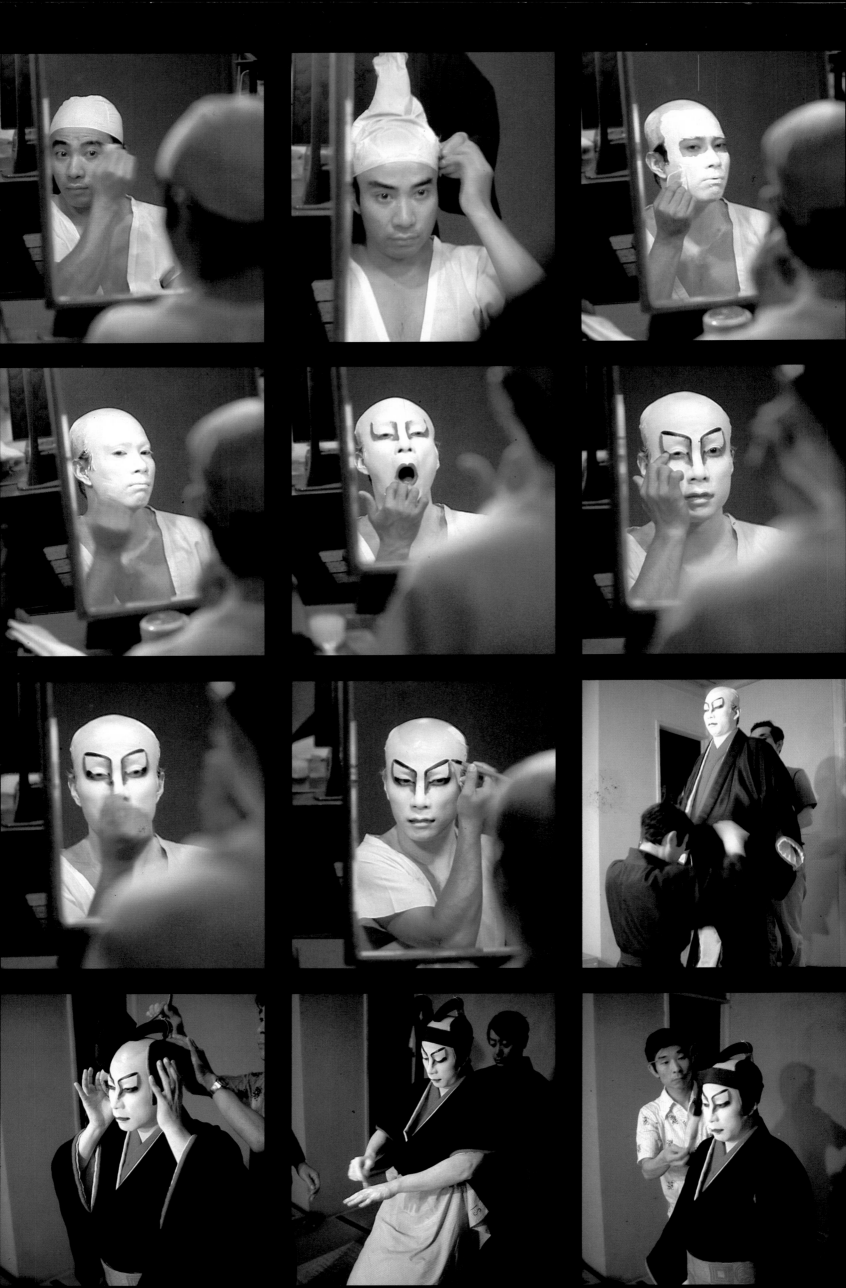

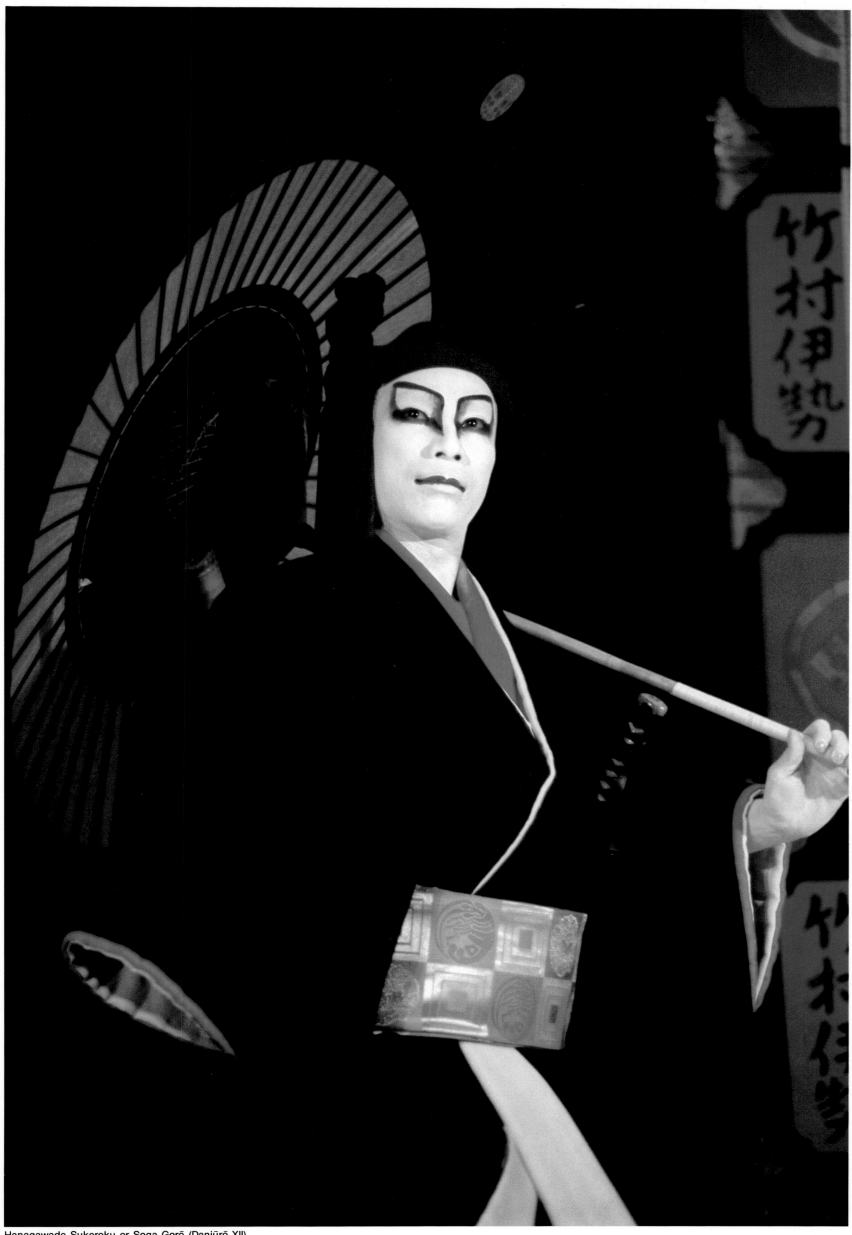

Hanagawado Sukeroku or Soga Gorō (Danjūrō XII)

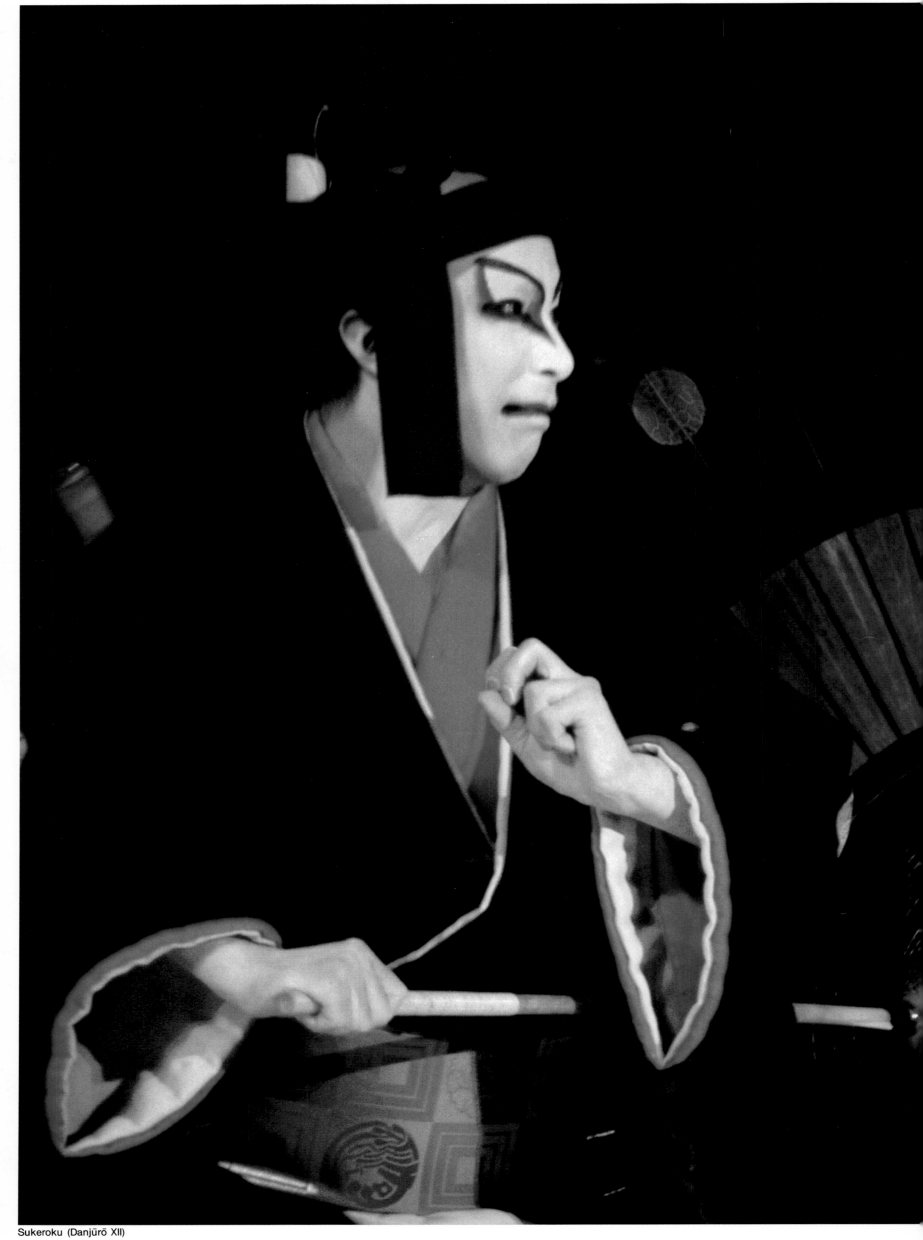

Sukeroku (Danjūrō XII)

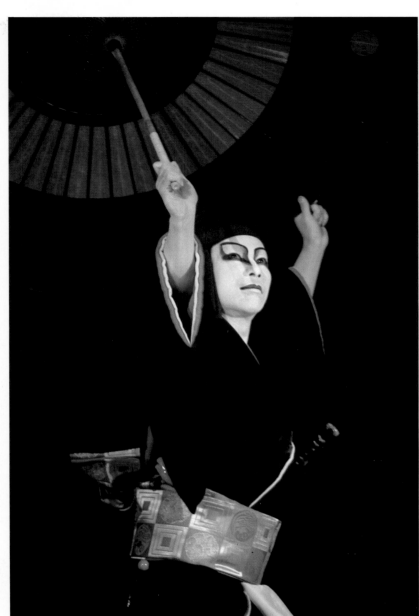

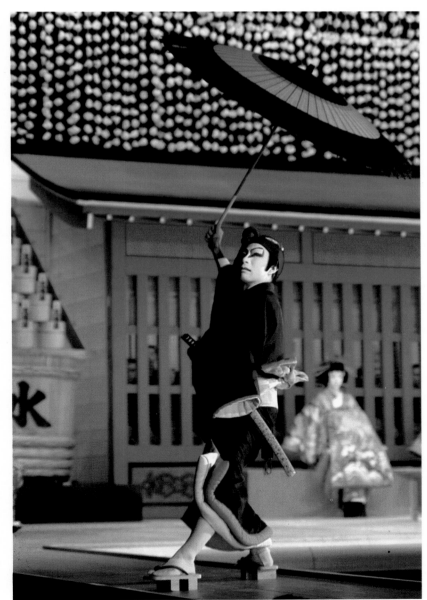

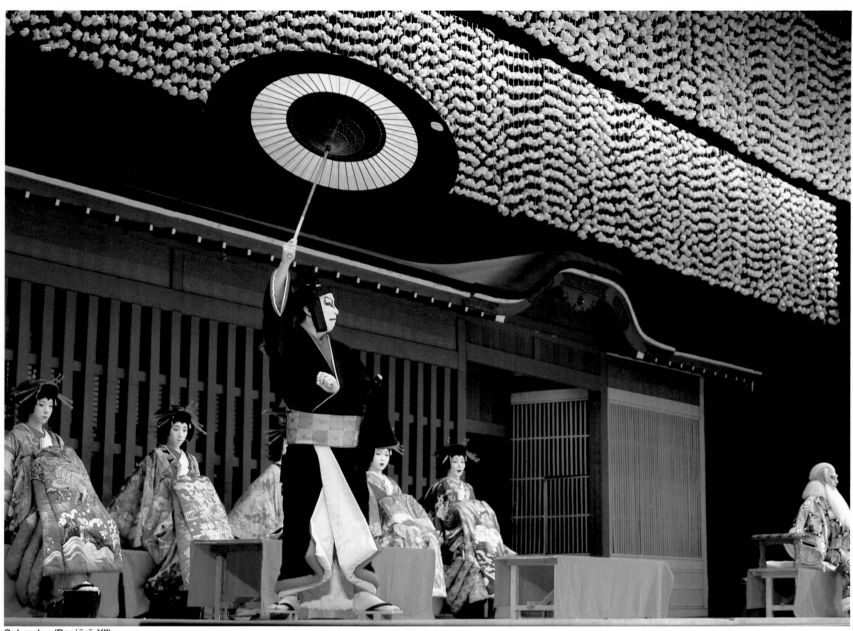
Sukeroku (Danjūrō XII)

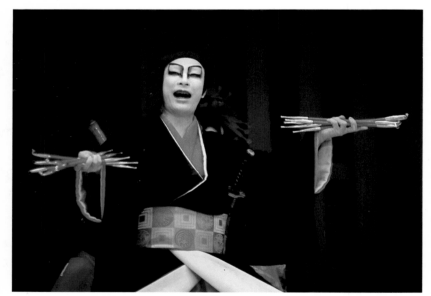

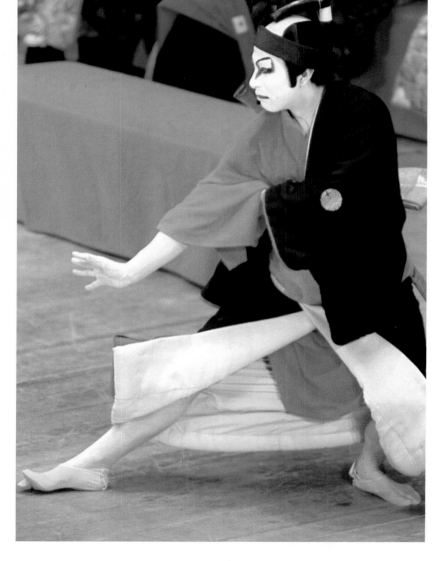

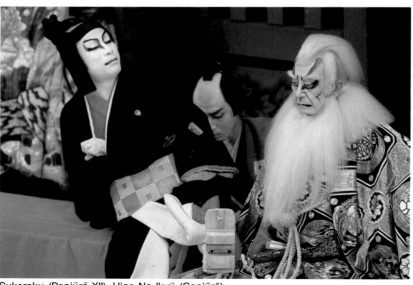
Sukeroku (Danjūrō XII), Hige No Ikyū (Gonjūrō)

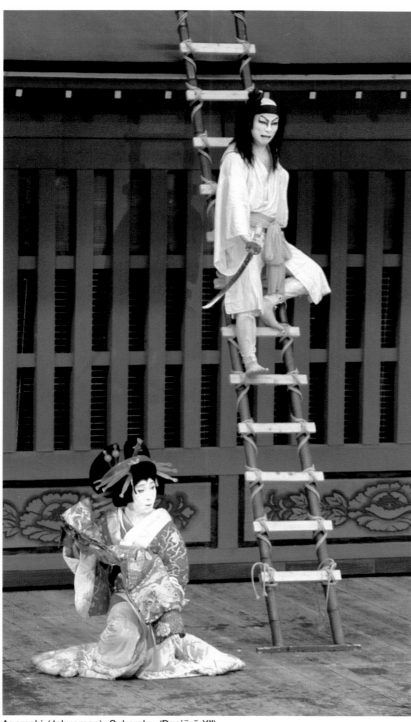

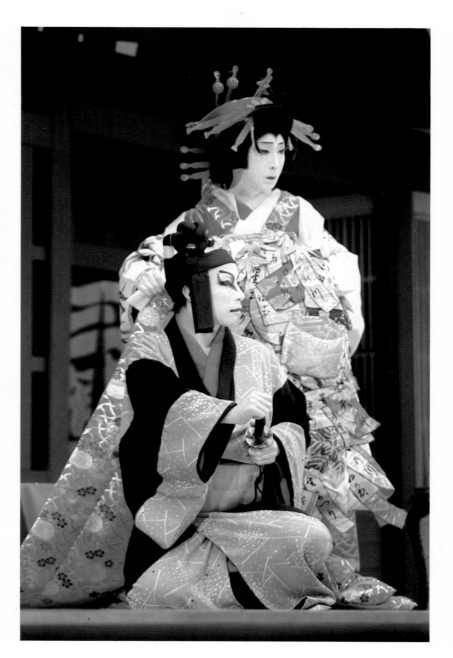

Agemaki (Jakuemon), Sukeroku (Danjūrō XII)

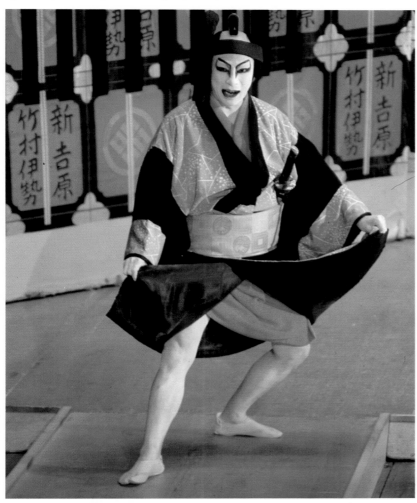

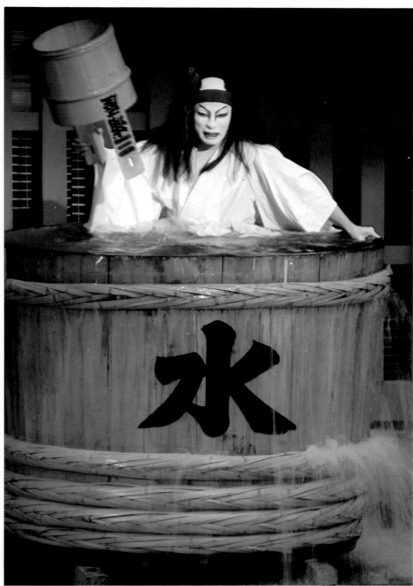

勧進帳
KANJINCHŌ

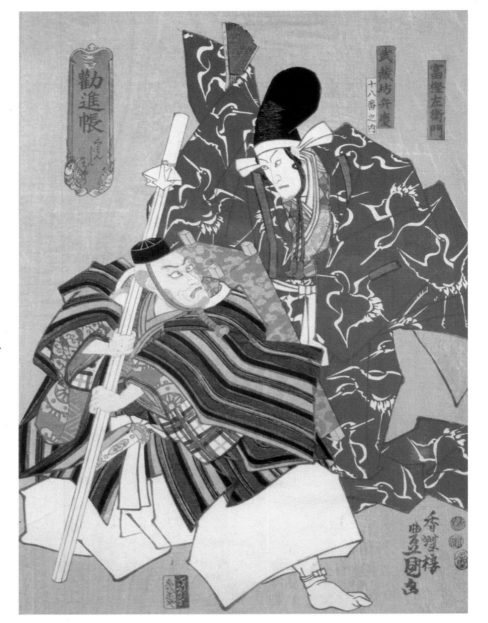

KANJINCHŌ (The Subscription List)

Ichikawa Danjūrō VII created this play which he based on a Nō play called "Ataka". It was first performed in 1840. Minamoto Yoshitsune is with his followers and his most faithful retainer Benkei, fleeing from the soldiers of his nasty and insecure brother, Yoritomo. He has to pass through the Ataka barrier to reach the northern part of Japan. Togashi who was warned by Yoritomo that Yoshitsune and his party would try to get through disguised as mountain priests is immediately suspicious when they arrive. Benkei announces that they are collecting money for the restoration of the Tōdai Temple in Nara but Togashi argues that if they were real priests they would have a subscription list. Benkei immediately produces one and skillfully "reads" it. Admiring his loyalty and presence of mind Togashi decides at this moment to let them pass through. He is by now enjoying their act and even offers to contribute to their fund. They are allowed to leave but then a guard warns Togashi that one of the priests looks like Yoshitsune. Togashi cannot ignore this and probably hopes that Benkei will save the situation. Benkei initially feebly argues that it is possible for people to look like others but then out of sheer despair strikes Yoshitsune with a wooden stick. In the end Benkei, who was treated to food and drink and performed a dance for Togashi leaves on the hanamichi quietly thanking him since he knows that Togashi will have to commit suicide.

By Utagawa Toyokuni III. Danjūrō VII as Musashibō Benkei and Danjūrō VIII as Togashi No Saemon. Benkei's garment has been changed to the present black kimono with gold Sanskrit letter pattern by Danjūrō XII. (The National Diet Library)

By Utagawa Toyokuni III. Danjūrō VII as Musashibō Benkei. In Kabuki a scroll is used for the account book (kanjinchō) of contributions to the religious institutions. Yoshitsune's life depends on Benkei's skillful reading of this blank scroll. (Waseda University Theater Museum)

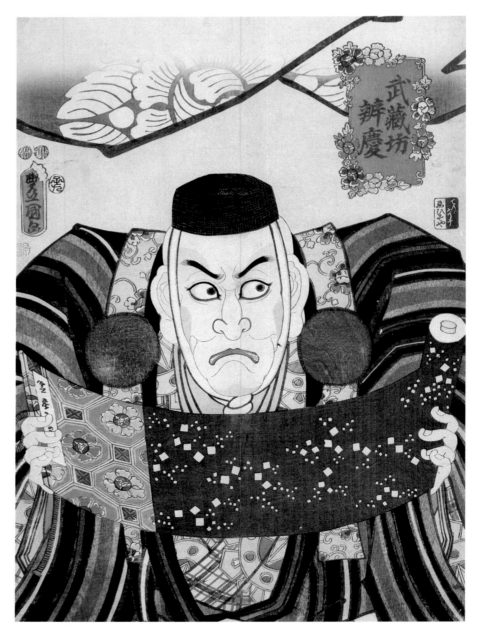

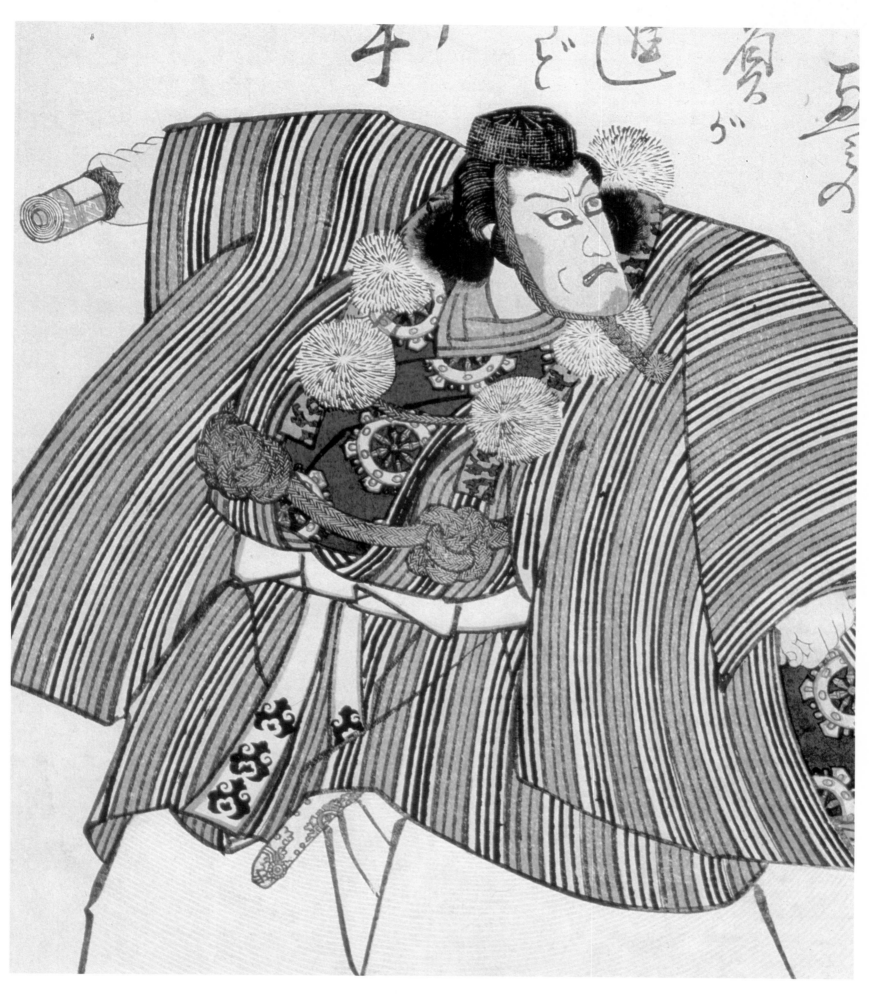

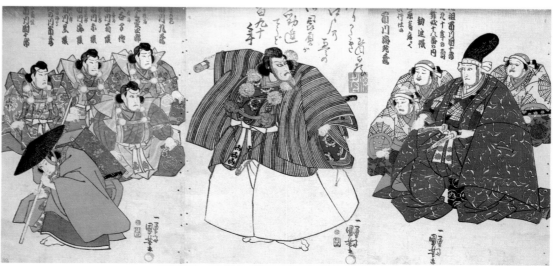

By Utagawa Kuniyoshi. Danjūrō VIII as Yoshitsune with his four followers, Danjūrō VII as Benkei and Ichikawa Kyūzō II as Togashi. (Waseda University Theater Museum)

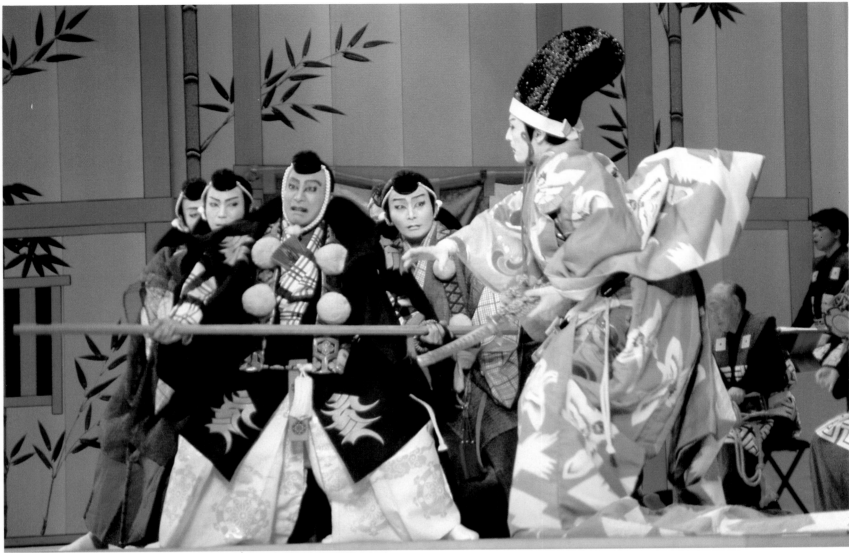

Benkei (Danjūrō XII)

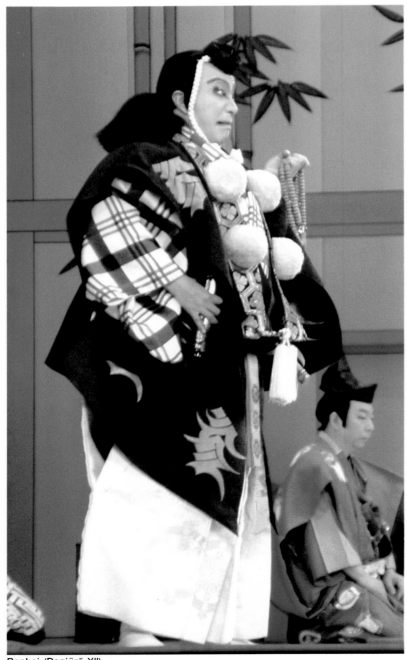

Benkei (Danjūrō XII)

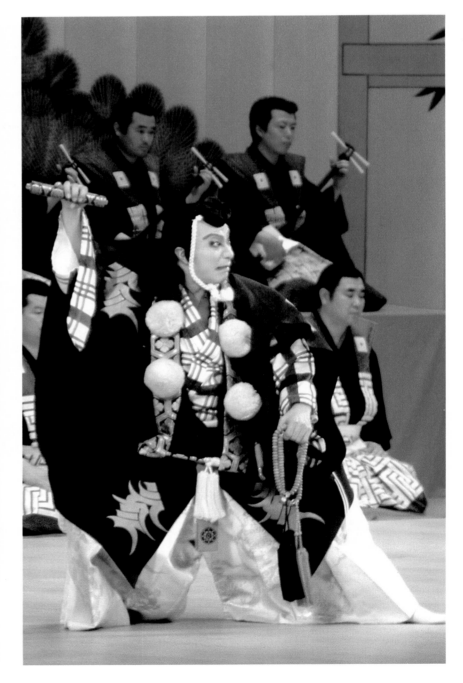

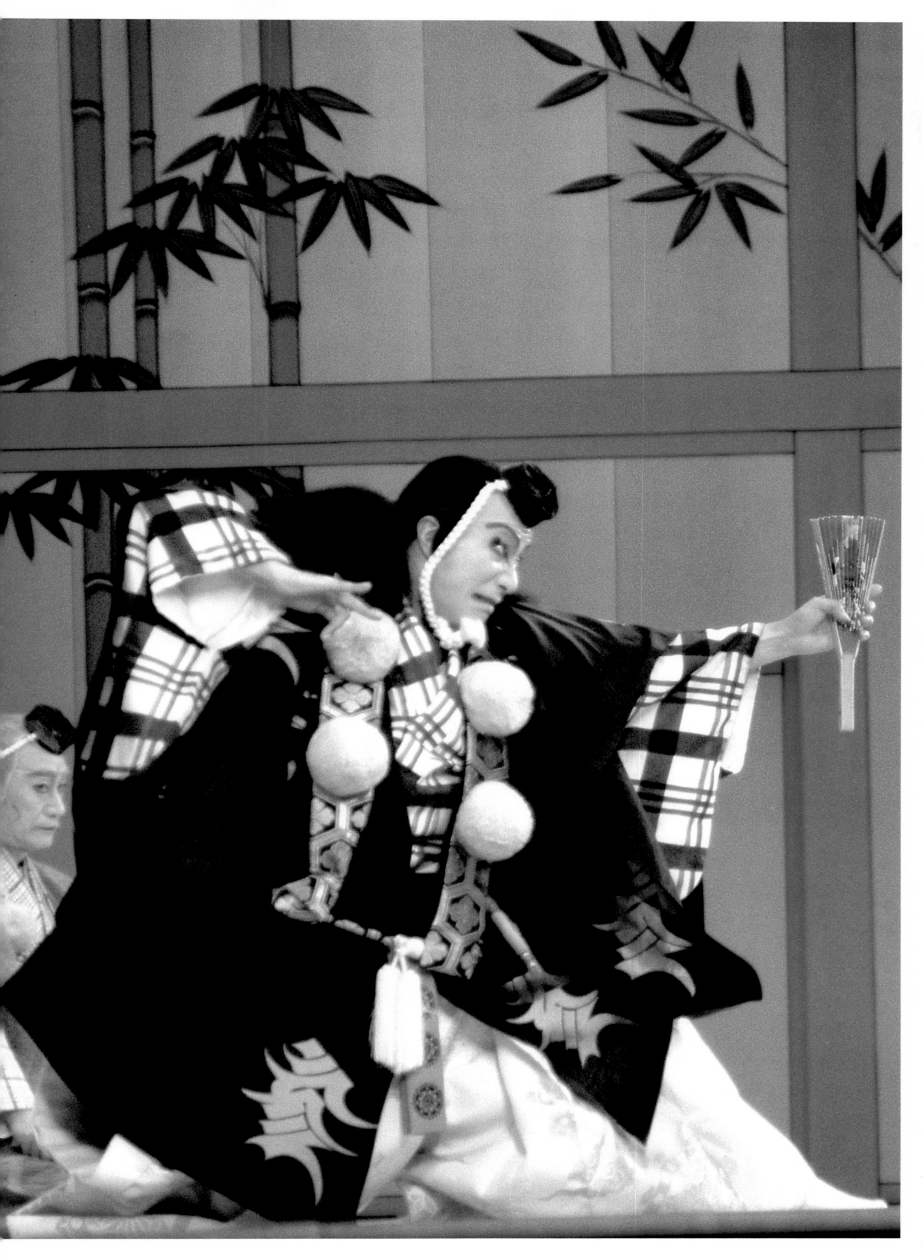

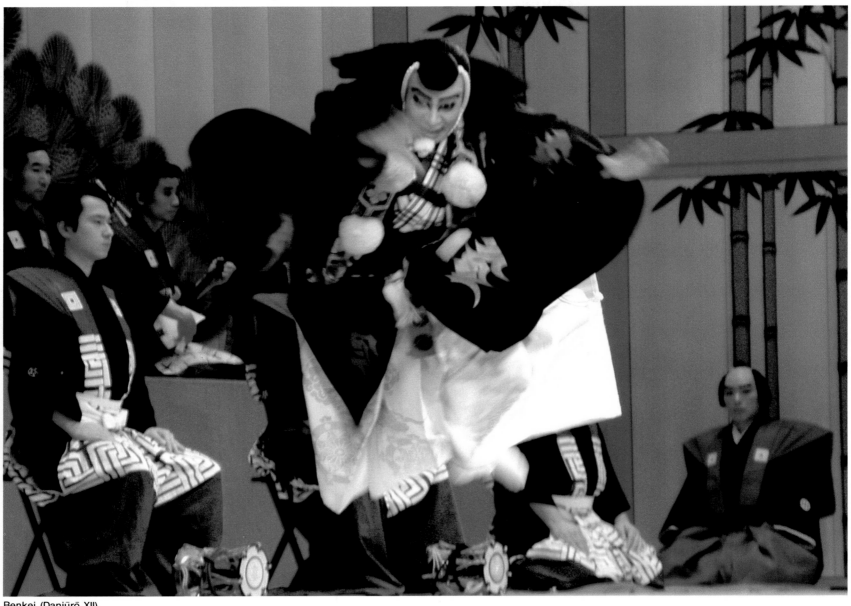

Benkei (Danjūrō XII)

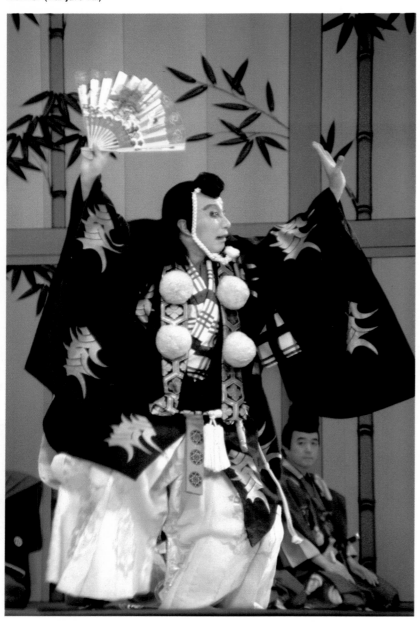

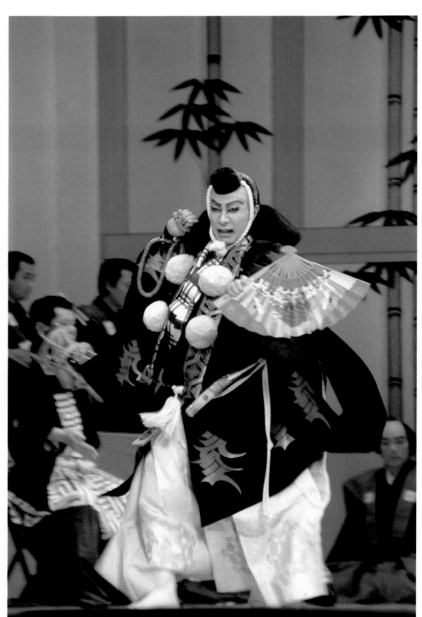

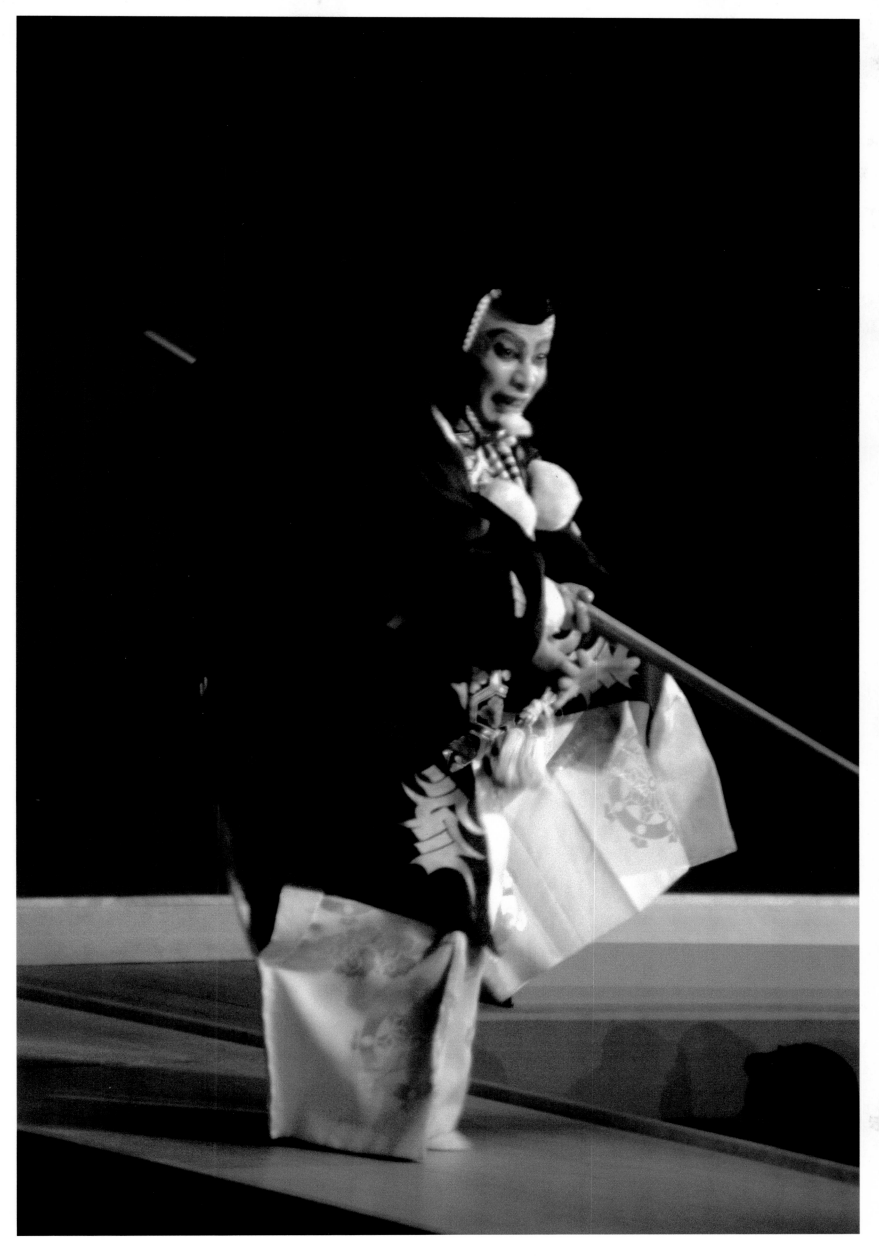

◼ PORTRAITS OF DANJŪRŌ I–IX

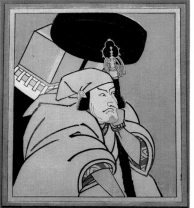

Danjūrō V in "Kamahige"

Danjūrō IX in "Kan-U"

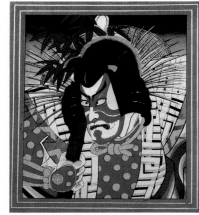

Danjūrō IX in "Oshimodoshi"

Danjūrō I in "Genroku Shibaraku"

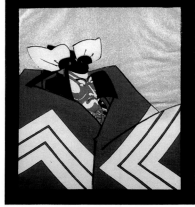

Danjūrō VI in "Shibaraku"

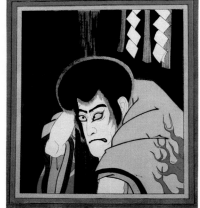

Danjūrō IX in "Fudō"

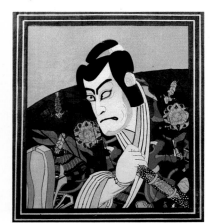

Danjūrō IX in "Kenuki"

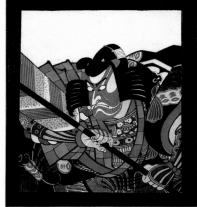

Danjūrō II in "Ya-No-Ne"

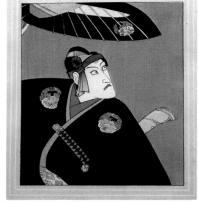

Danjūrō VII in "Sukeroku"

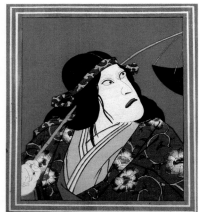

Danjūrō IX in "Narukami"

Danjūrō IX in "Jayanagi"

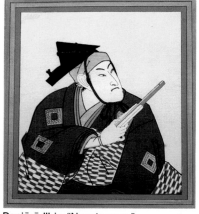

Danjūrō III in "Nanatsumen"

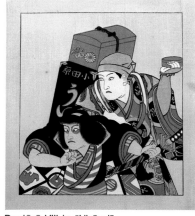

Danjūrō VIII in "Uirōuri"

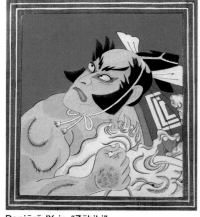

Danjūrō IX in "Zōhiki"

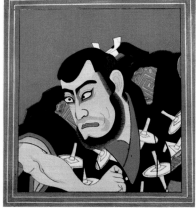

Danjūrō IX in "Fuwa"

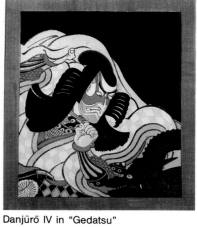

Danjūrō IV in "Gedatsu"

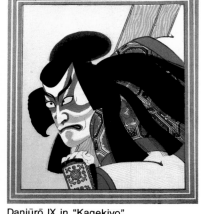

Danjūrō IX in "Kagekiyo"

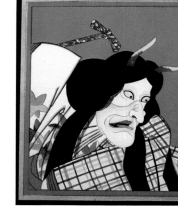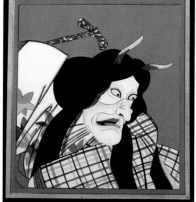

Danjūrō IX in "Uwanari"

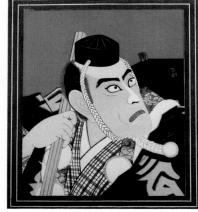

Danjūrō IX in "Kanjinchō"

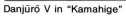

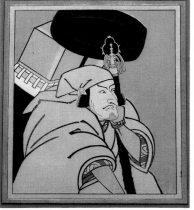

KENUKI

KENUKI (Tweezers)

"Kenuki" was originally performed as a part of "Narukami Fudō Kitayamazakura" and like "Fudō" and "Narukami" it was later performed as an independent play. To kill time, Danjō, a messenger, pulls out his beard with tweezers which suddenly come to life. There is also a lady whose hair stands on end. Danjō, guessing the reason for her strange illness, throws a spear at the ceiling and a spy who holds a compass in his hands falls down. This trick accomplished with a magnet delighted the 18th century audience.

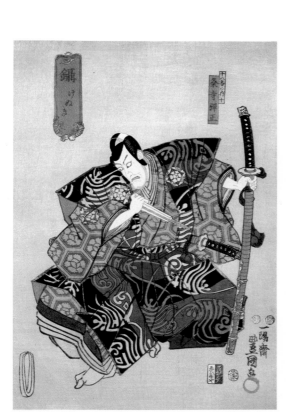

By Utagawa Toyokuni III. Danjūrō VII as Kumedera Danjō. A startled Danjō is gazing at the upright pair of tweezers that helped him to solve the mystery. Over the tortoise-shell-patterned kimono he wears a stiff sleeveless cape and a kind of trousers with a design of a lobster in the shape of the Chinese character "kotobuki" (congratulations). The present outfit was first worn by Ichikawa Sadanji II during his revival of this play at the Meiji-za in September 1909. (The National Diet Library)

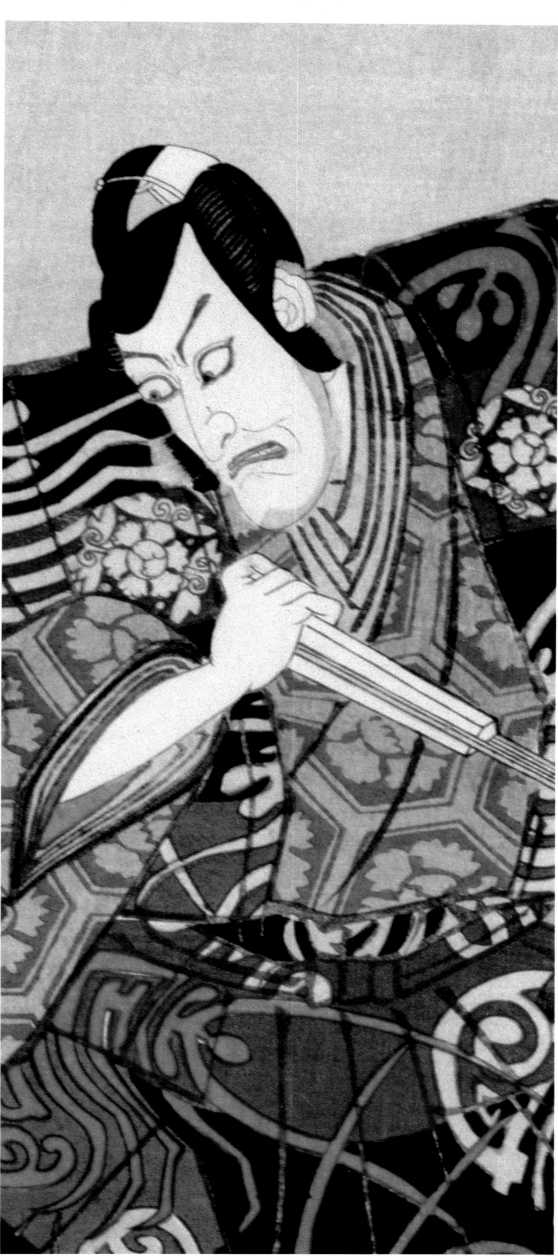

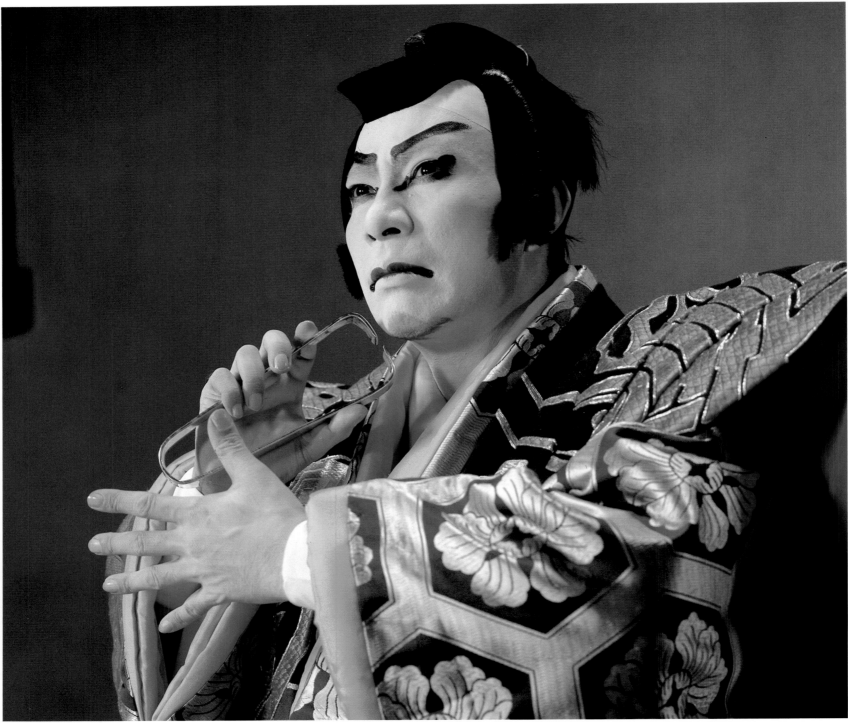

Kumedera Danjō (Danjūrō XII)

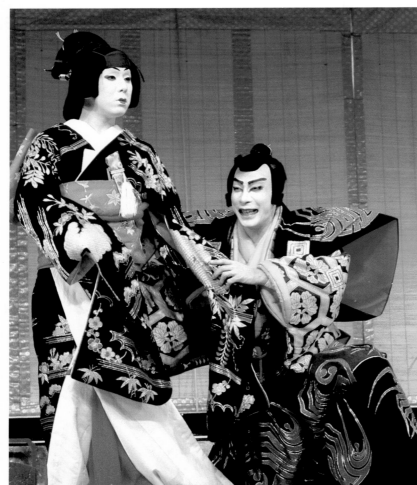

Makiginu (Kankurō), Danjō (Danjūrō XII)

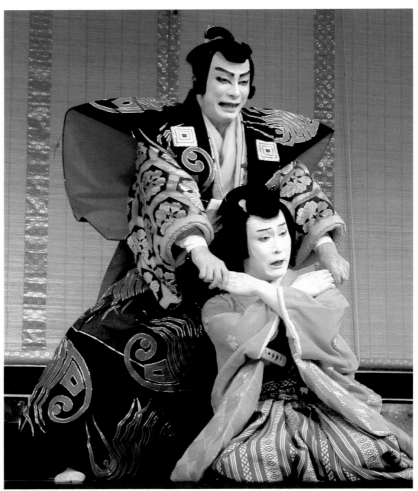

Danjō (Danjūrō XII), Hidetarō (Tomoemon)

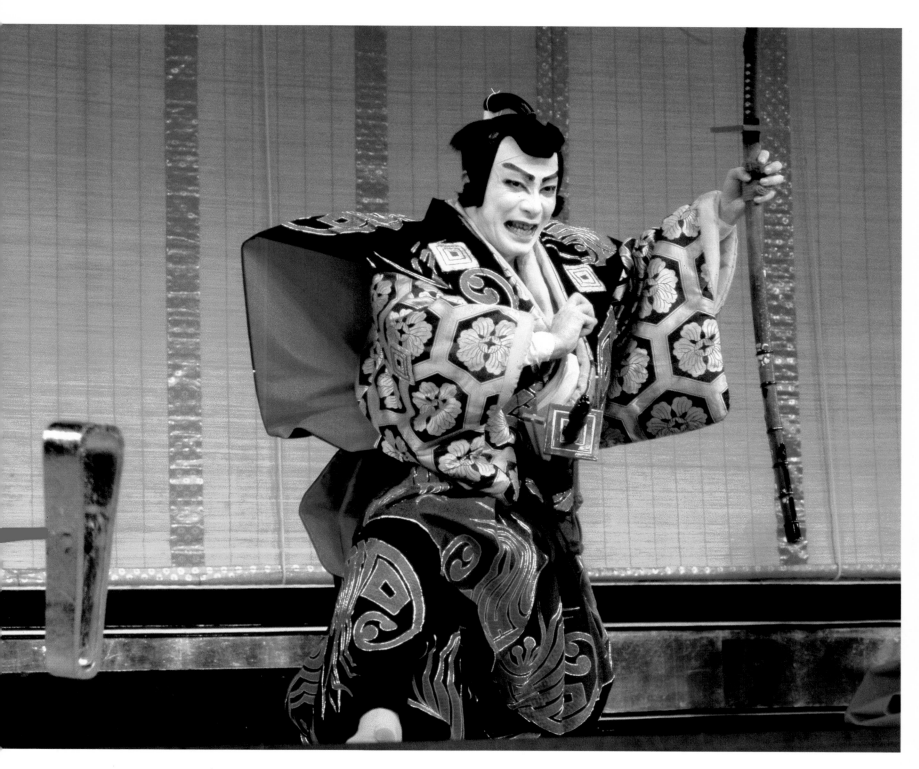

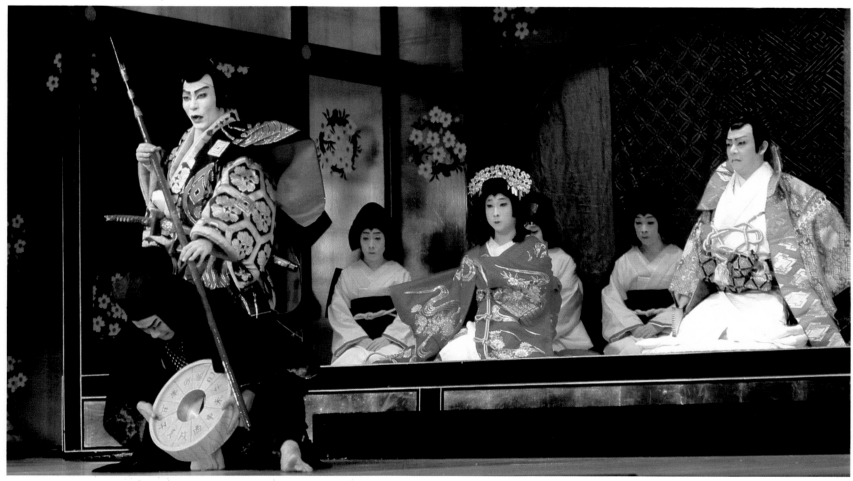

Narukami (Danjūrō XII), Kumo No Taemahime (Tamasaburō)

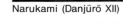

Narukami (Danjūrō XII)

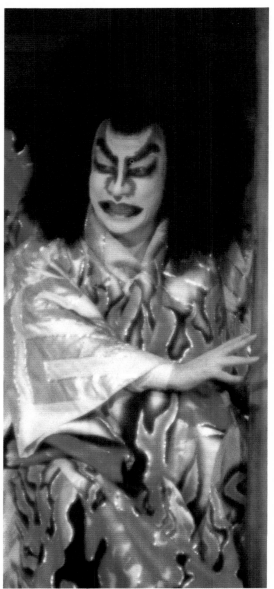

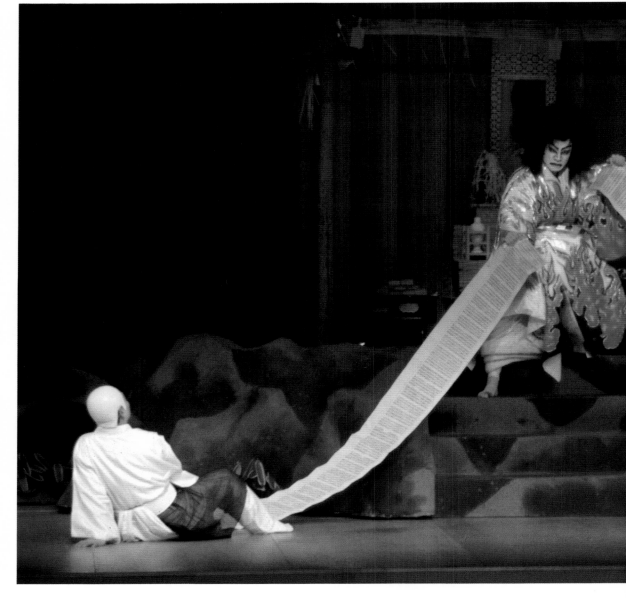

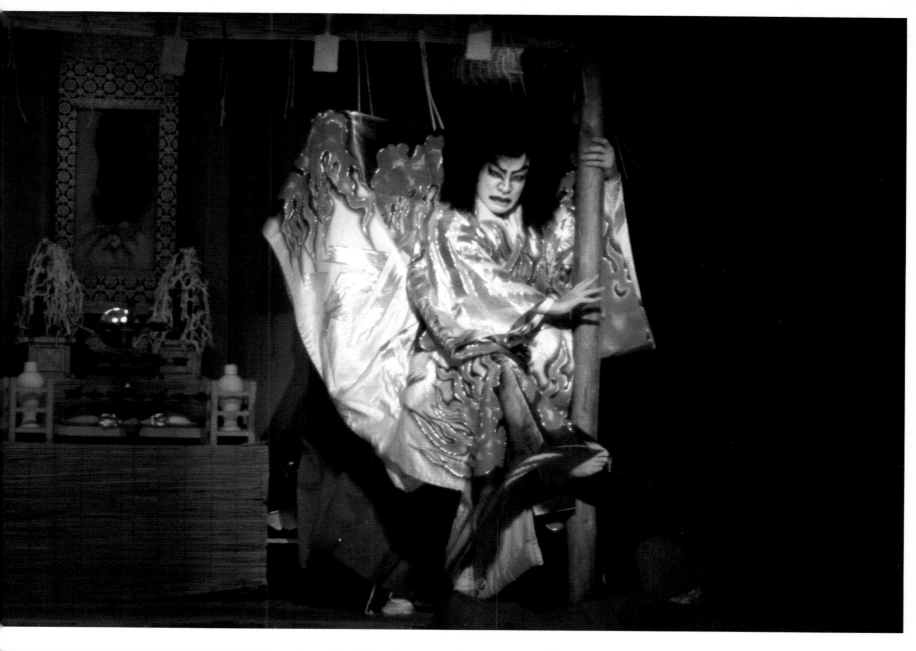

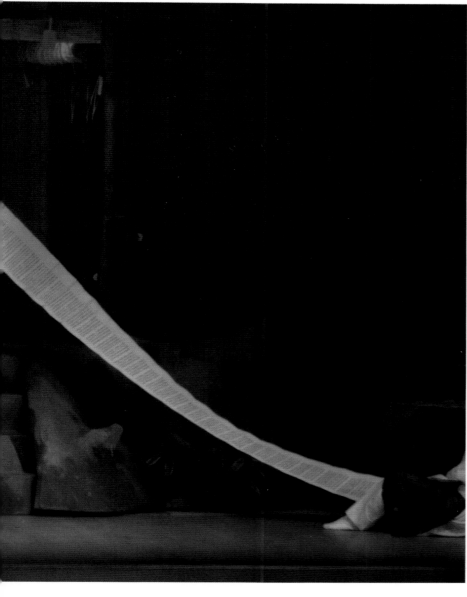

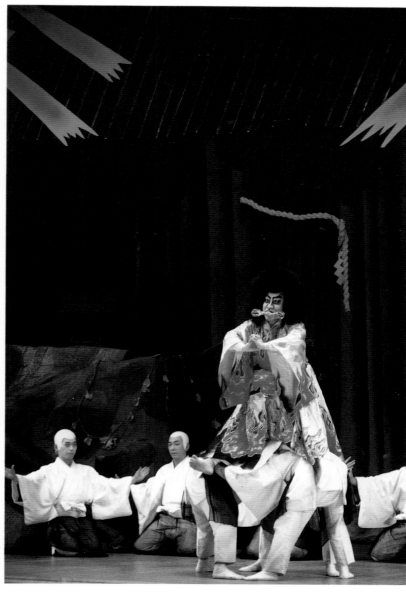

Kamakura Gongorō and his father, Danjūrō VII, as Uke at the
Kawarazaki-za in November 1832. (Waseda University
Theater Museum)

Kamakura Gongorō (Danjūrō XII)

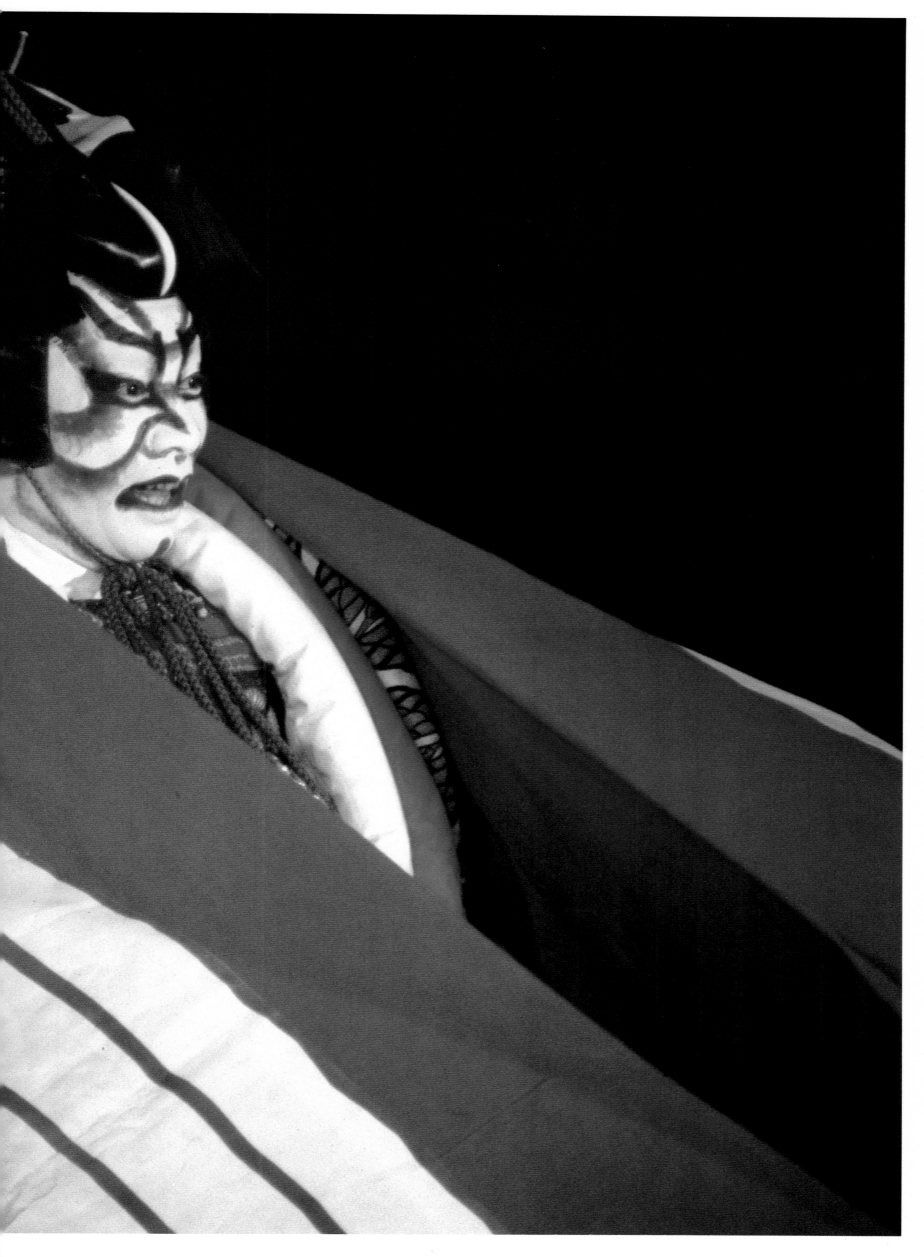

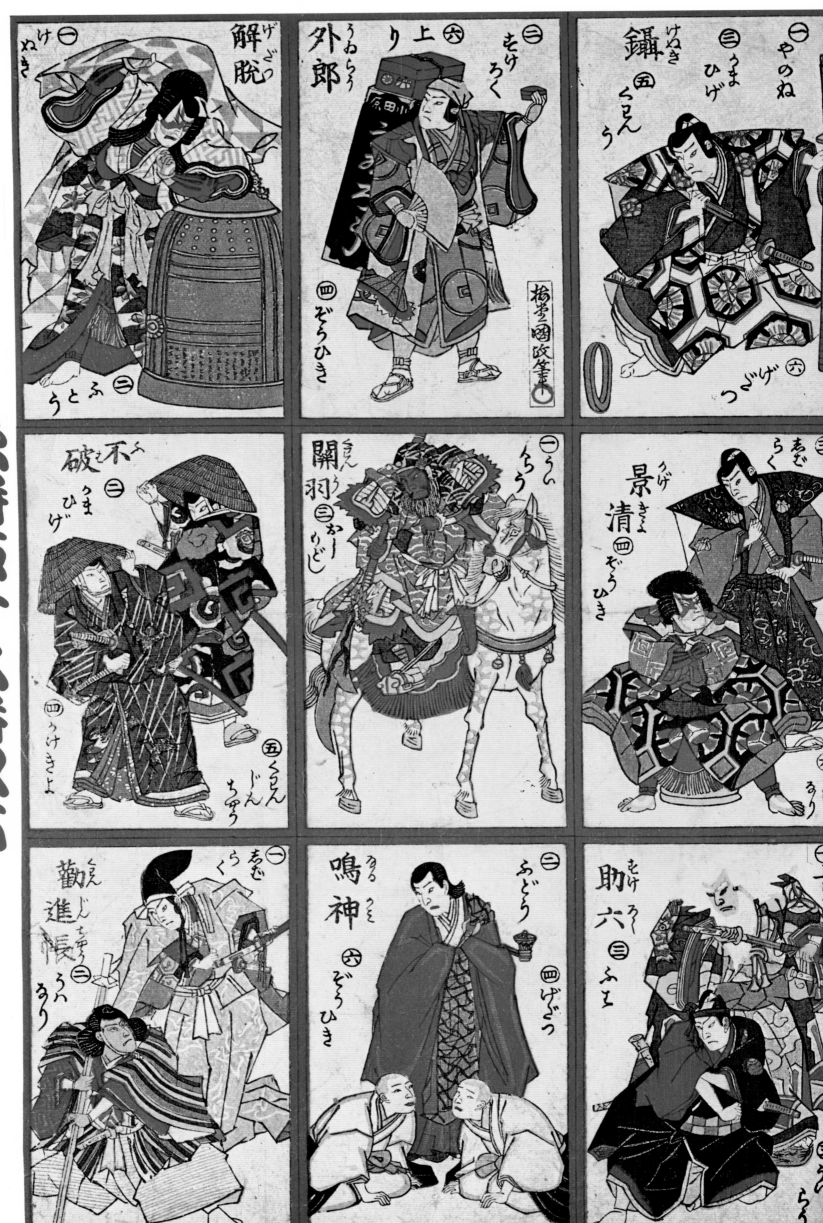

歌舞伎十八番双六

"KABUKI EIGHTEEN" DICE GAME

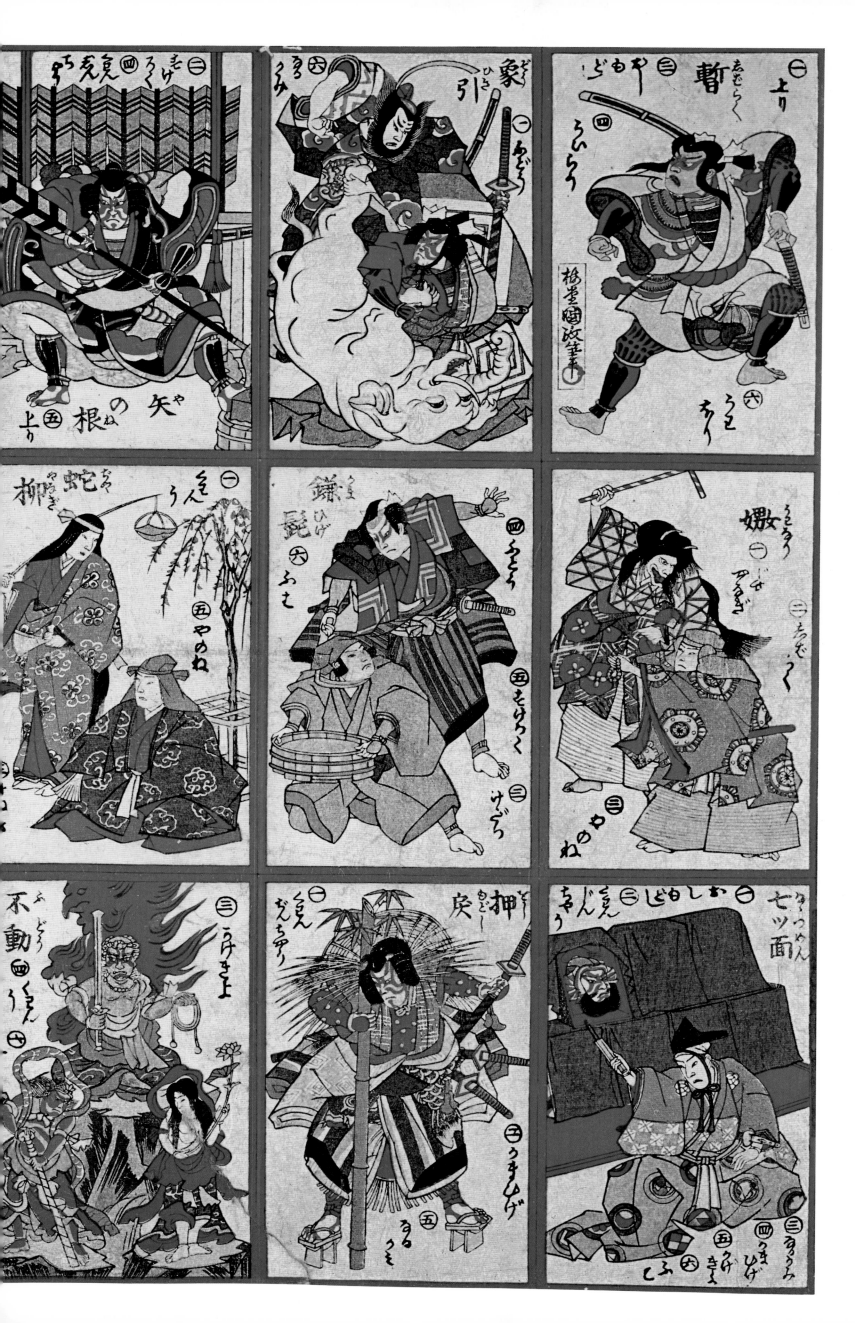

KAGEKIYO

KAGEKIYO (Kagekiyo)

Akushichibyōe Kagekiyo, a Heike general whose loyalty and courage impressed even his enemy, the Genji, is one of the most popular historical characters and appears in numerous Nō, puppet theater and Kabuki plays. In this piece, Kagekiyo who has been trying to kill Yoritomo, is brought to Kamakura and imprisoned. His enemies are looking for the heirlooms of the Heike clan and they bring Kagekiyo's wife and daughter and force them to play the koto and lute to find out whether they are lying or not since they say that they do not know where the treasures are. Later, when they are attacked, Kagekiyo breaks out of prison and in the true "ara-goto" style defends them and challenges his opponents to a fight on the battlefield.

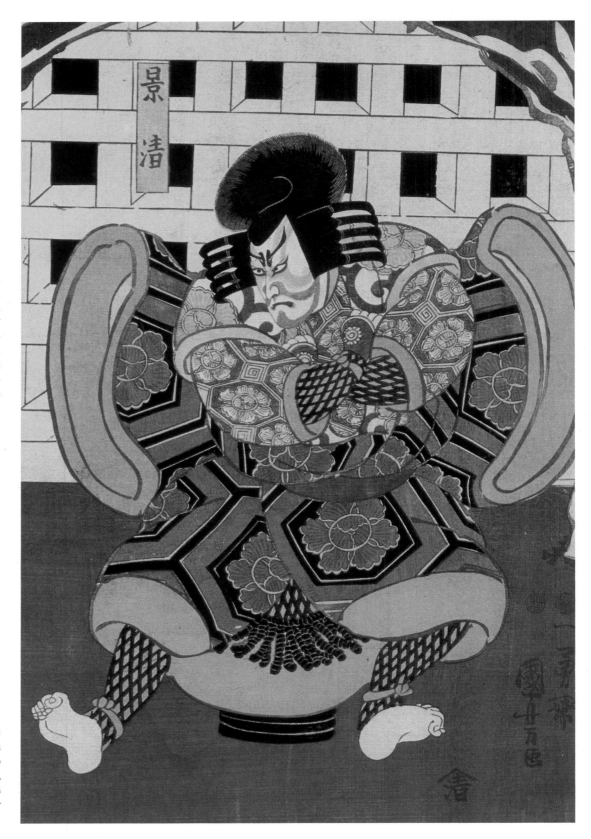

By Utagawa Kuniyoshi. Kajiwara Kagetoki, Chichibu Shigetada (Hikosaburō); Kagekiyo (Danjūrō VIII); Akoya (Kikujirō), Iwanaga. In August 1849, Danjūrō VIII returned to Edo (Tokyo) from Osaka and made his debut with Kagekiyo, announcing that he had learned this role in Osaka from his father, Danjūrō VII (then Ebizō). (Waseda University Theater Museum)

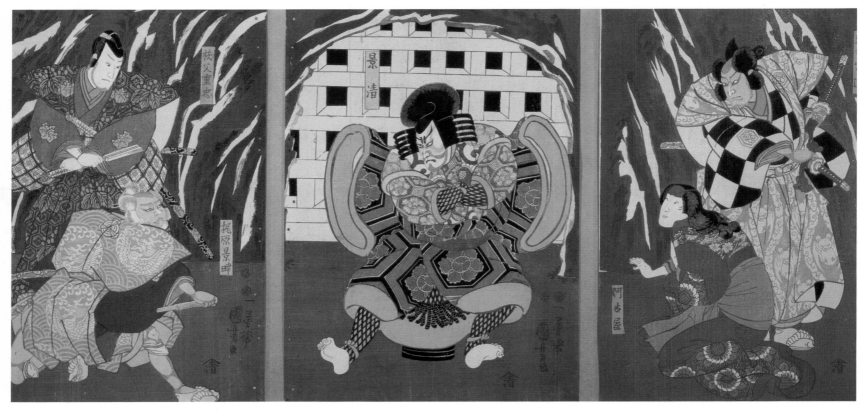

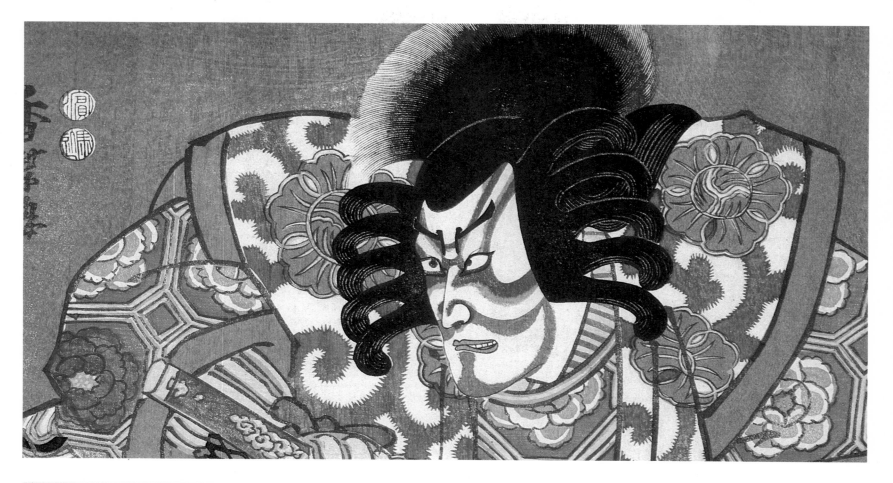

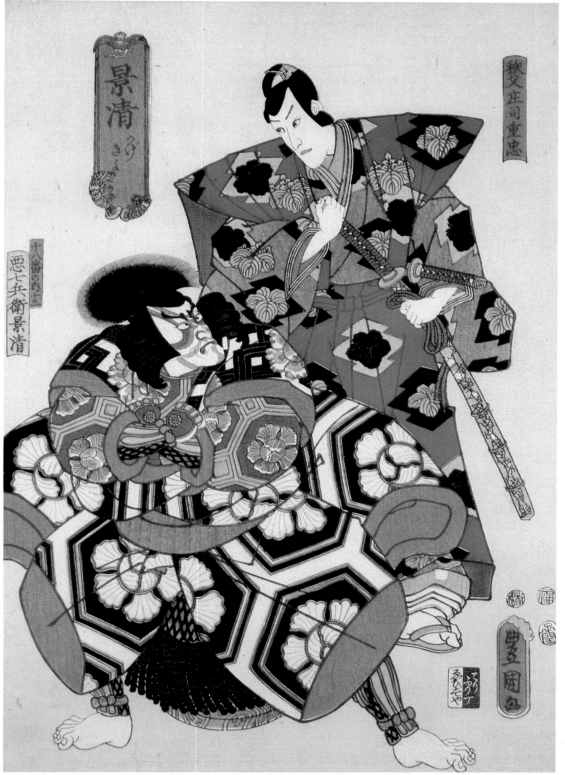

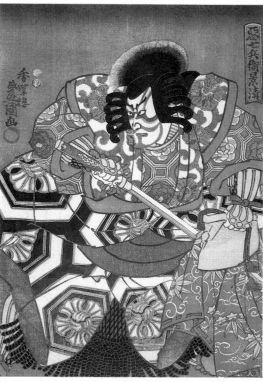

By Utagawa Toyokuni III. Danjūrō VIII as Kagekiyo. Danjūrō VIII was considered to be a very handsome and eloquent actor. (Waseda University Theater Museum)

By Utagawa Toyokuni III. Akushichibyōe Kagekiyo (Danjūrō VII) and Chichibu Shōji Shigetada (Danjūrō VIII). Danjūrō VII wore a warrior's suit of armor when he performed this play as one of the "Kabuki Eighteen" at the Kawarazaki-za in March 1832. It contributed to his banishment from Edo because of his extravagant way of life. Danjūrō VIII used riveted body armor. Danjūrō IX never performed this play because he thought that it would bring him bad luck. (The National Diet Library)

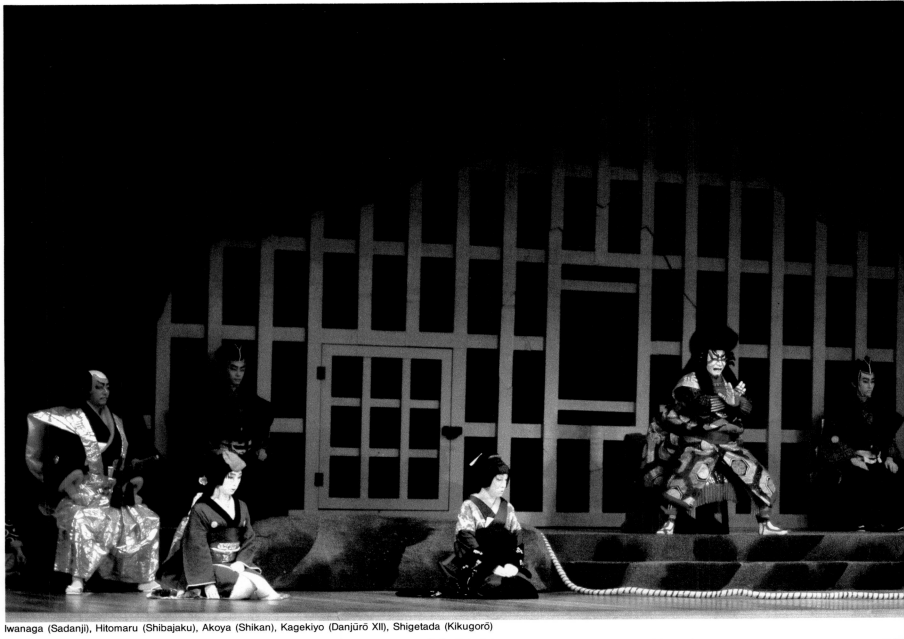

Iwanaga (Sadanji), Hitomaru (Shibajaku), Akoya (Shikan), Kagekiyo (Danjūrō XII), Shigetada (Kikugorō)

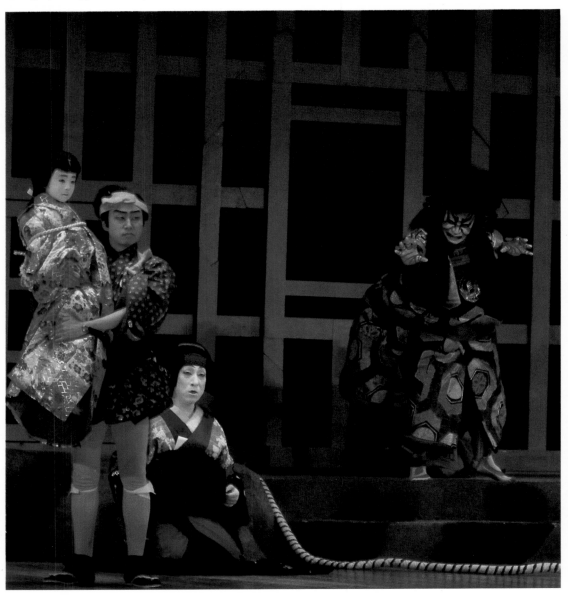

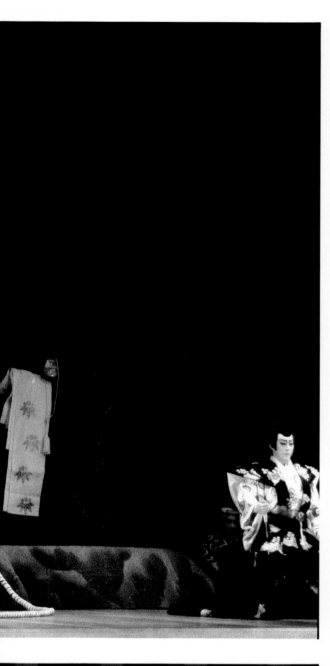

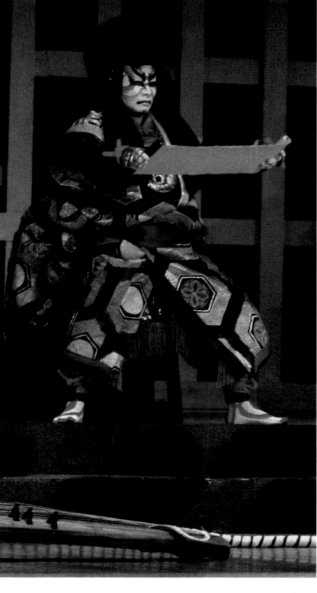

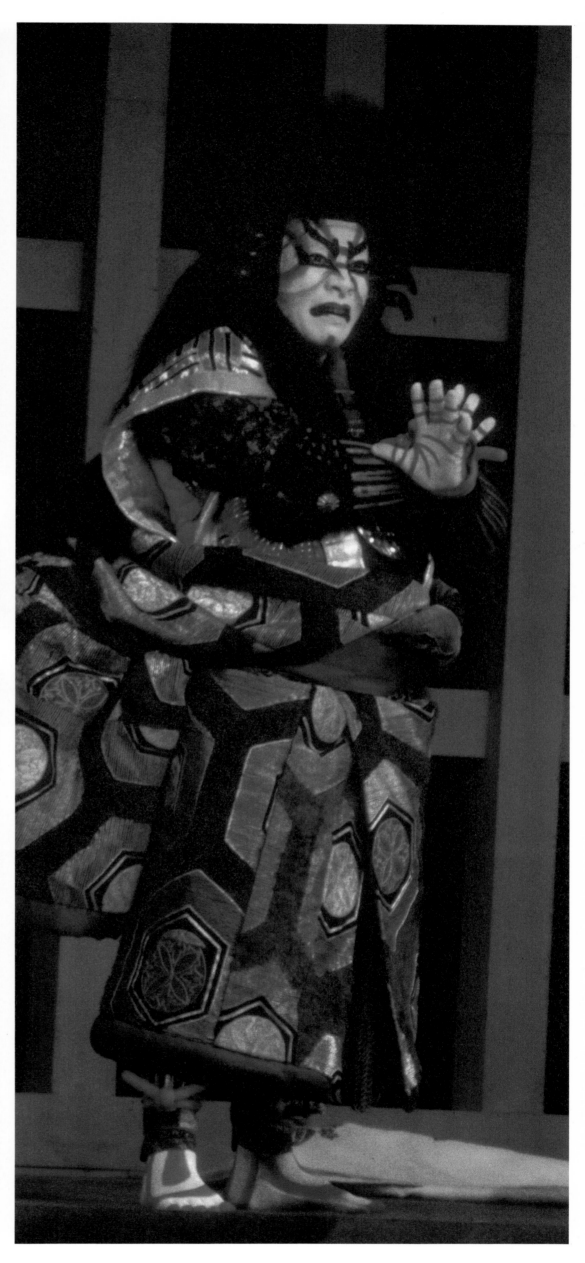

外郎売
UIRŌURI

UIRŌURI (The Medicine Vender)

A medicine from Odawara used for treating a cold was Ichikawa Danjūrō II's favorite drug. He would come on stage and deliver a two thousand word commercial which delighted the audience. It used to be performed as a part of "Sukeroku".

In 1949 Ichikawa Danjūrō XI revised it and made a new story which has Soga Gorō disguised as the medicine peddler and Soga Jūrō as a travelling monk. The Soga brothers are looking for Kudō Suketsune, the murderer of their father.

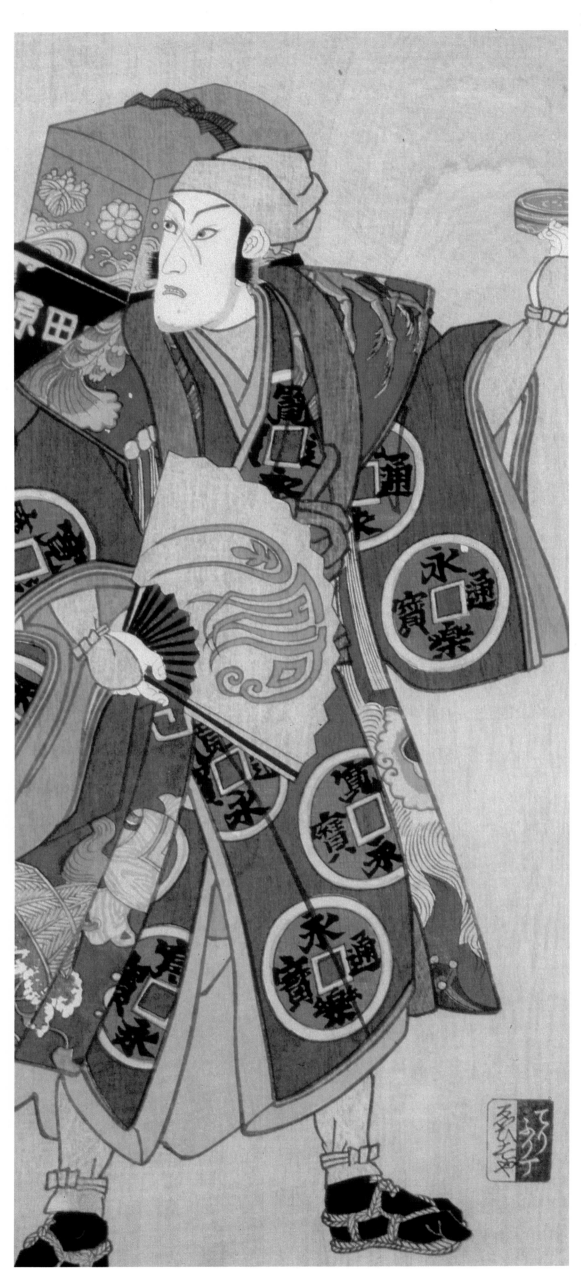

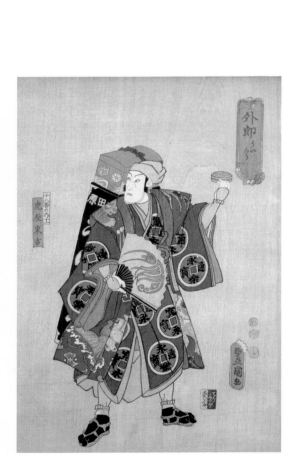

By Utagawa Toyokuni III. Danjūrō VIII as Toraya Tōkichi. He was ten years old when he performed this role in his new name announcement celebration performance of "Sukeroku" in 1832. (National Diet Library)

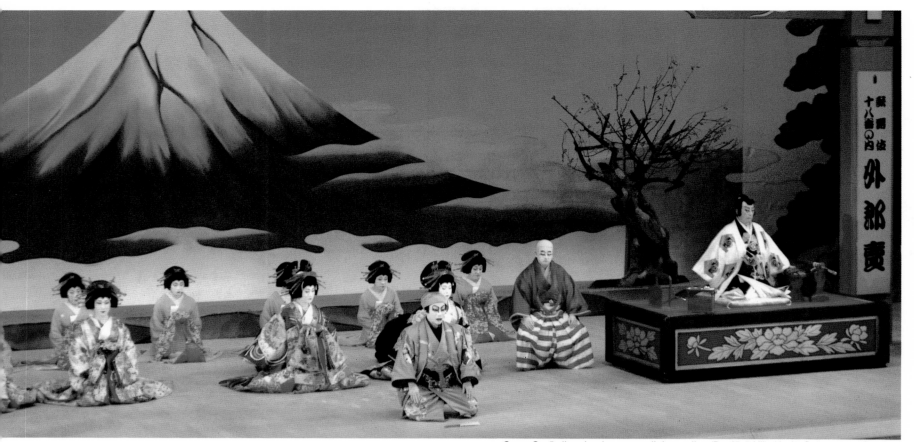

Soga Gorō disguised as a medicine seller (Danjūrō XII), Kudō Suketsune (Gonjūrō)

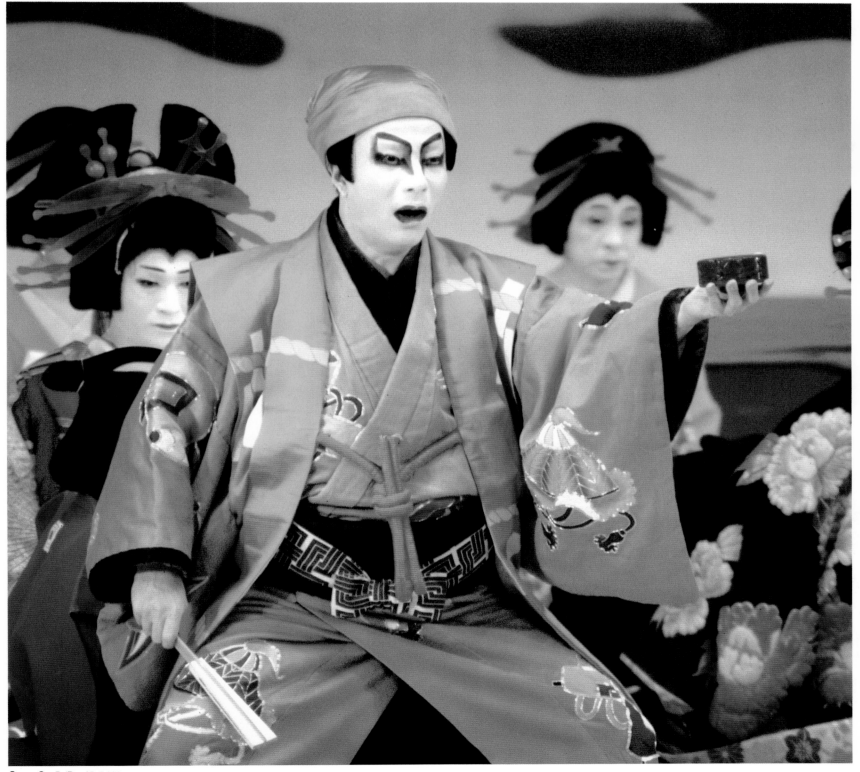

Soga Gorō (Danjūrō XII)

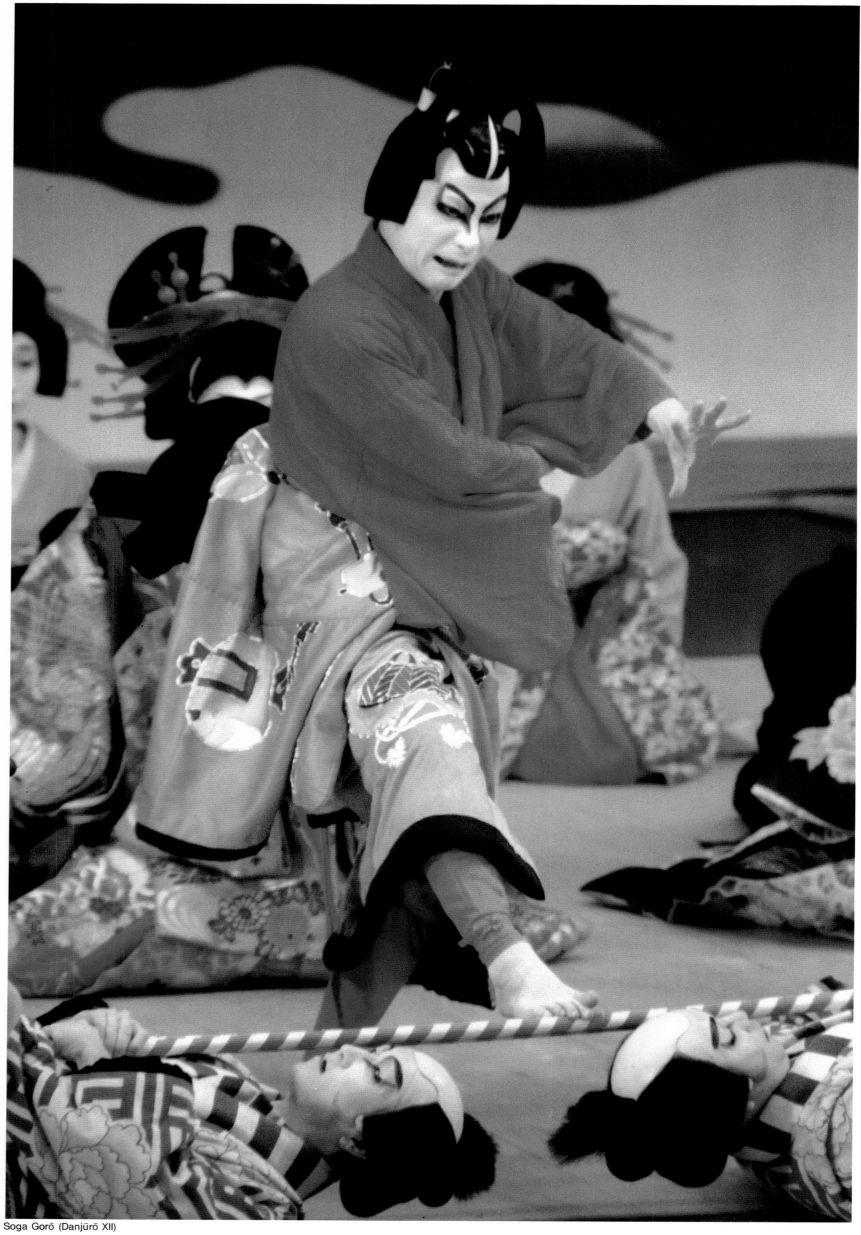

Soga Gorō (Danjūrō XII)

OSHIMODOSHI

OSHIMODOSHI (The Enforced Retreat)

One of the most spectacular of the "Kabuki Eighteen" it was well received when first performed in 1727 by Ichikawa Danjūrō II. An angry demon is pushed back to the stage by a warrior who appears on the "hana-michi". The hero wears the most elaborate "suji-kuma" makeup, gauntlets and greaves and an enormous padded kimono. He walks around on high wooden clogs carrying three swords and a bamboo spear. The demon is not far behind with his long, red wig and Nō style brocade costume.

The "oshi-modoshi" role can be seen in plays like "Futaomote", "Dōjōji" and "Onna Naru-kami" but on a smaller scale.

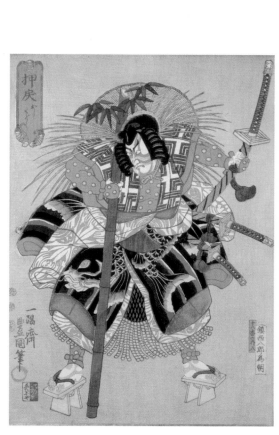

By Utagawa Toyokuni III. This drawing is of Danjūrō VIII as Chinzei Hachirō Tametomo, although the "oshimodoshi" character of this play is also known under names like Take-nuki Gorō or Ōdate Samagorō. His visage is worthy of the hero of a bravado-style play. (The National Diet Library)

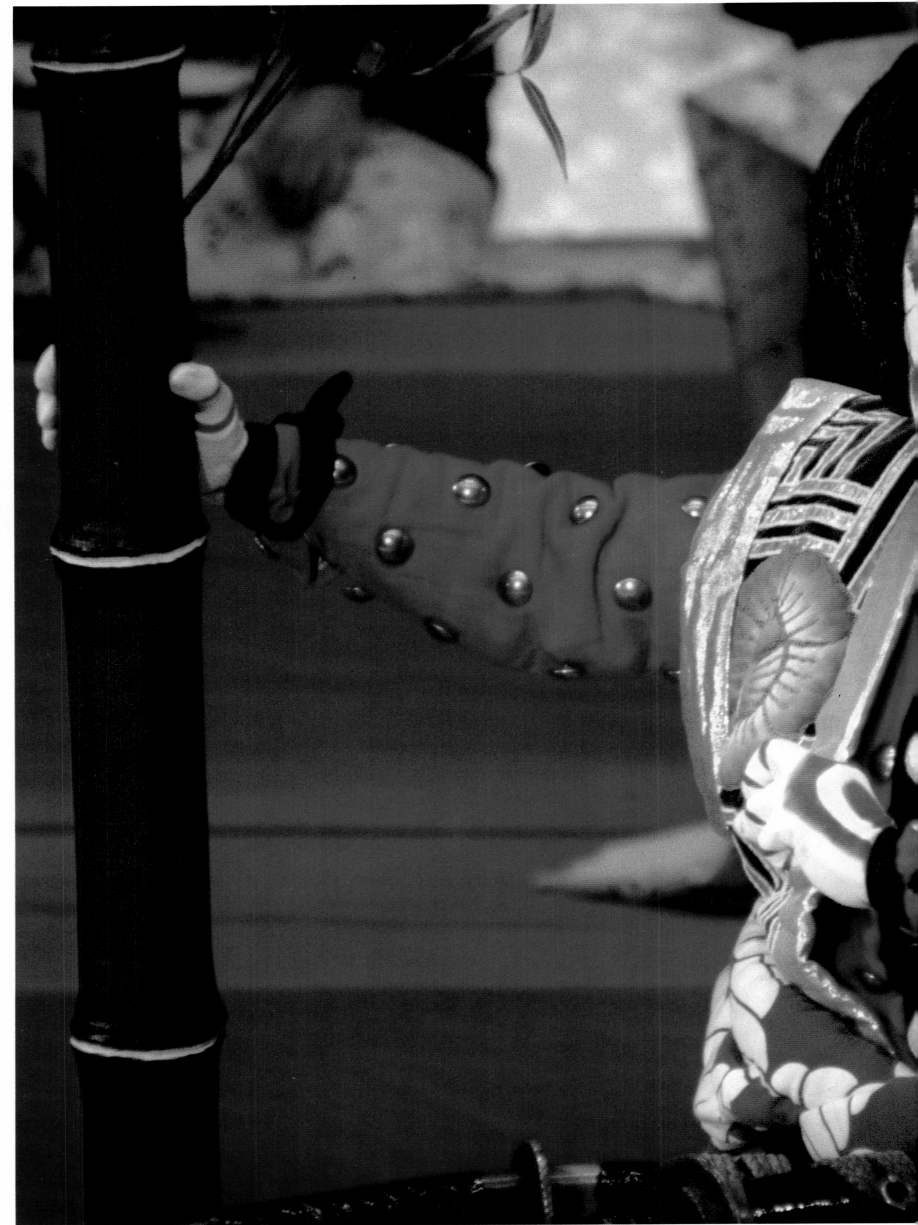

Ōdate Samagorō (Danjūrō XII)

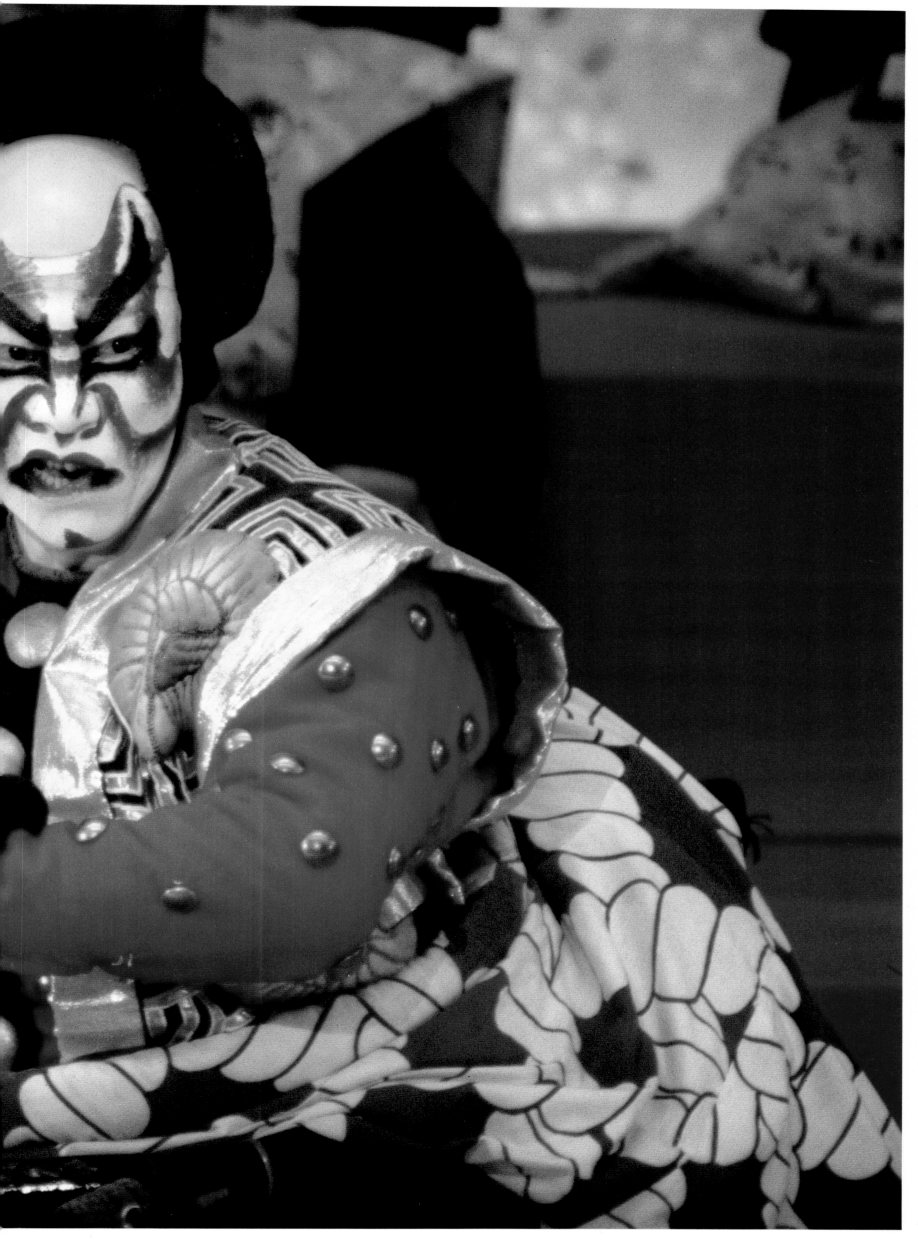

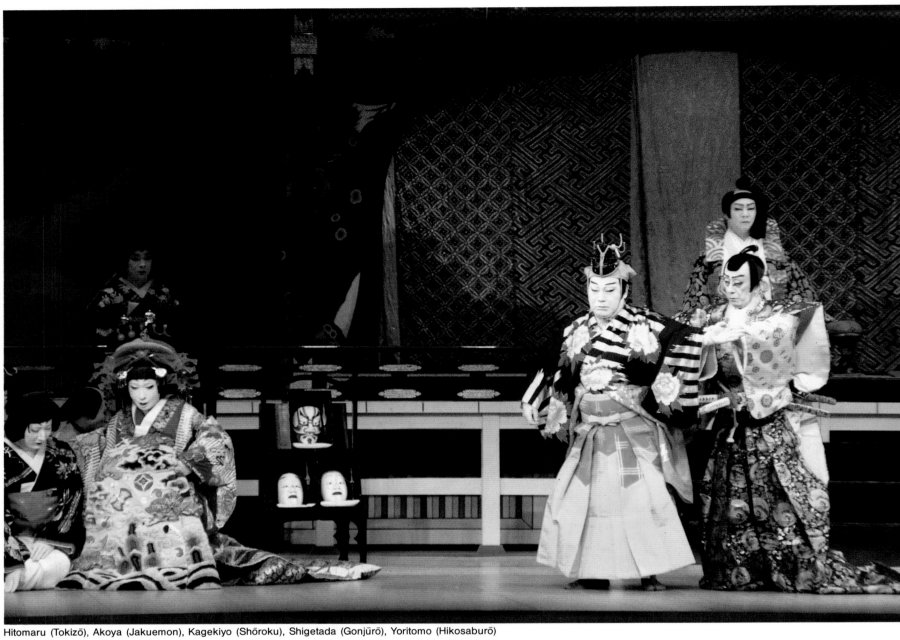

Hitomaru (Tokizō), Akoya (Jakuemon), Kagekiyo (Shōroku), Shigetada (Gonjūrō), Yoritomo (Hikosaburō)

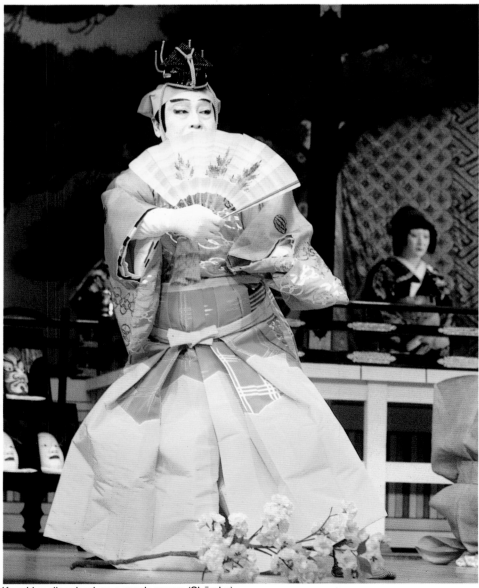

Kagekiyo disguised as a mask carver (Shōroku)

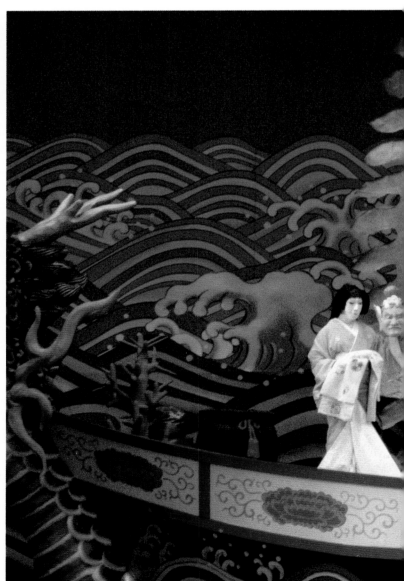

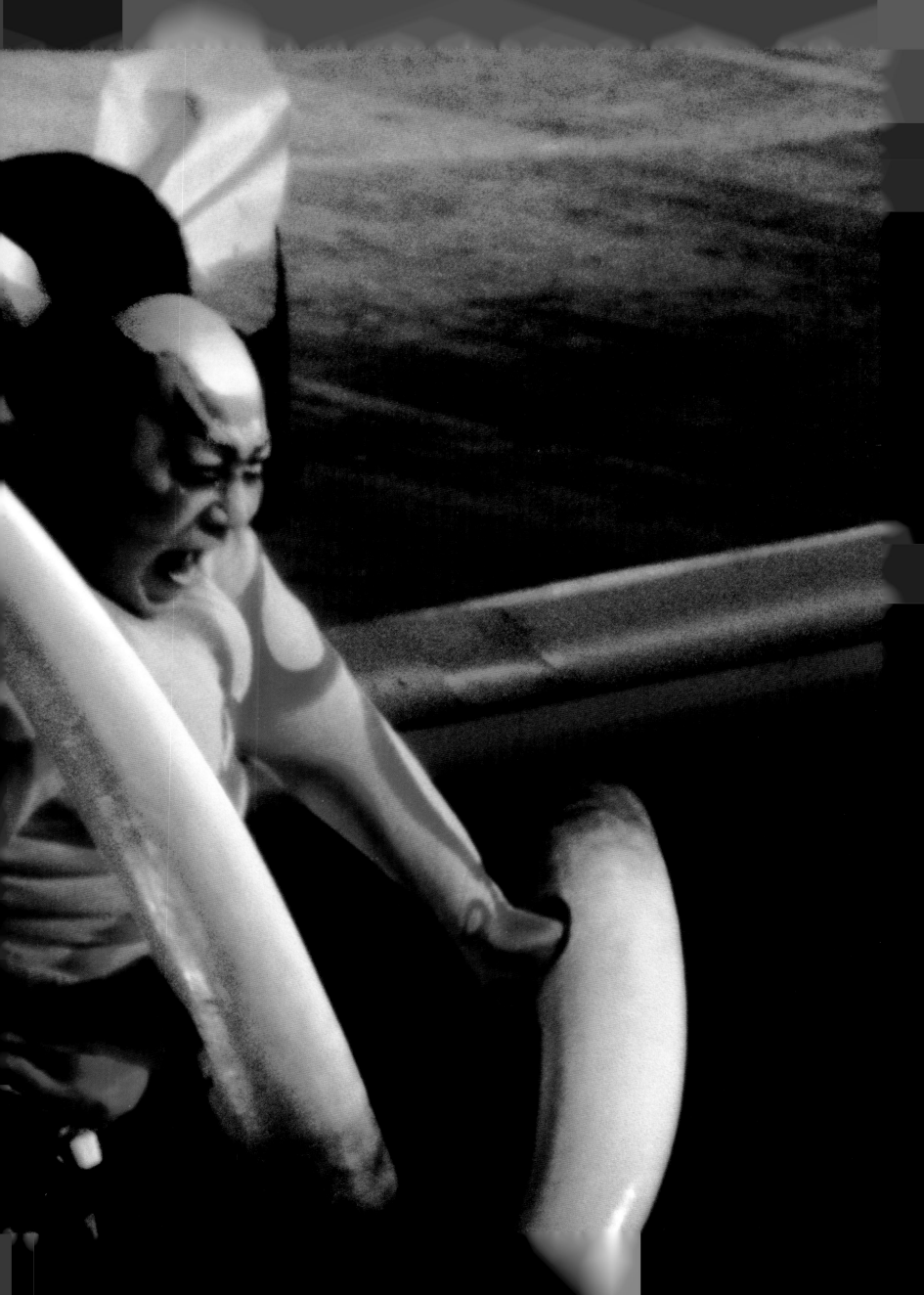

矢の根
YA-NO-NE

By Utagawa Toyokuni III. Danjūrō VII as Soga Gorō Tokimune is seen sharpening the arrowhead. This play, one of a number that deals with the Soga brothers, is always presented in the most spectacular way. (The National Diet Library)

YA-NO-NE (The Arrowhead)

This play was first staged in 1729 at the Nakamura-za in Edo by Ichikawa Danjūrō II.

Soga Gorō Tokimune, a hotheaded younger brother of Jūrō Sukenari, is celebrating the New Year. He dreams that his brother is in danger. He steals a horse and using a radish as the whip, rides off to help him at the house of Kudō Suketsune, the murderer of their father.

To avenge their father's death, the Soga brothers (c. 12th century) who boldly killed Suketsune when he was on a hunting expedition on Mt. Fuji with Minamoto Yoritomo, are celebrated in numerous plays of Kabuki repertoire traditionally staged in January. This piece is a perfect example of the exaggerated gestures and Kabuki beauty.

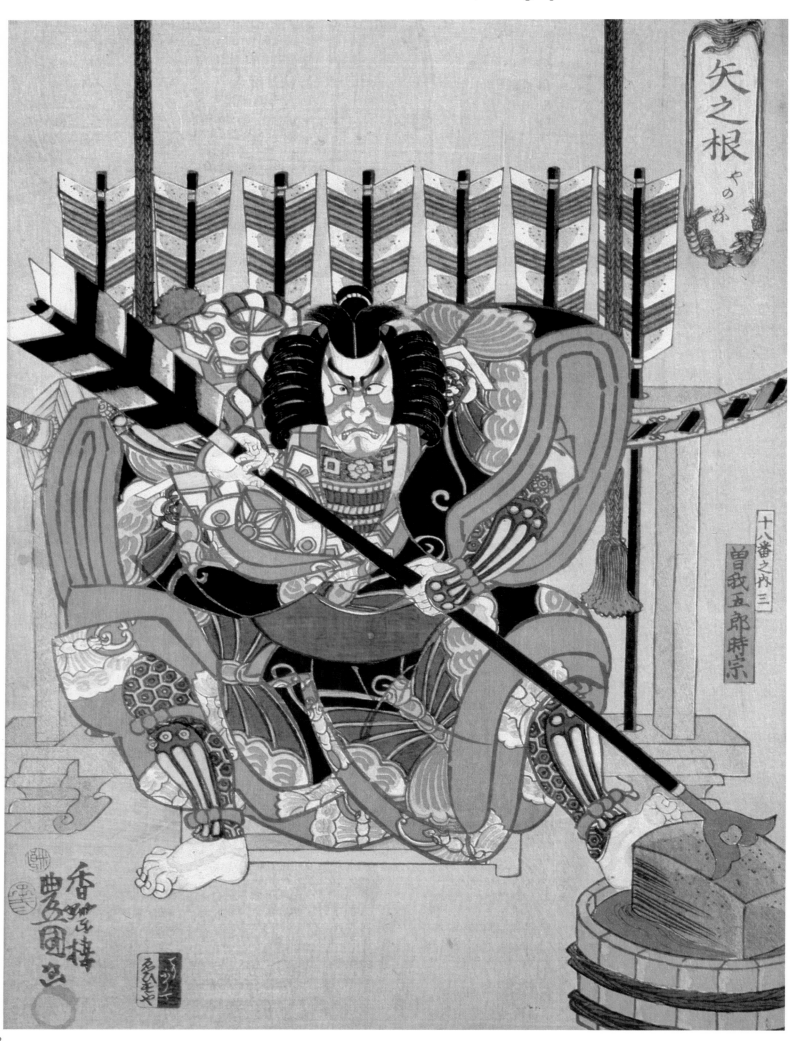

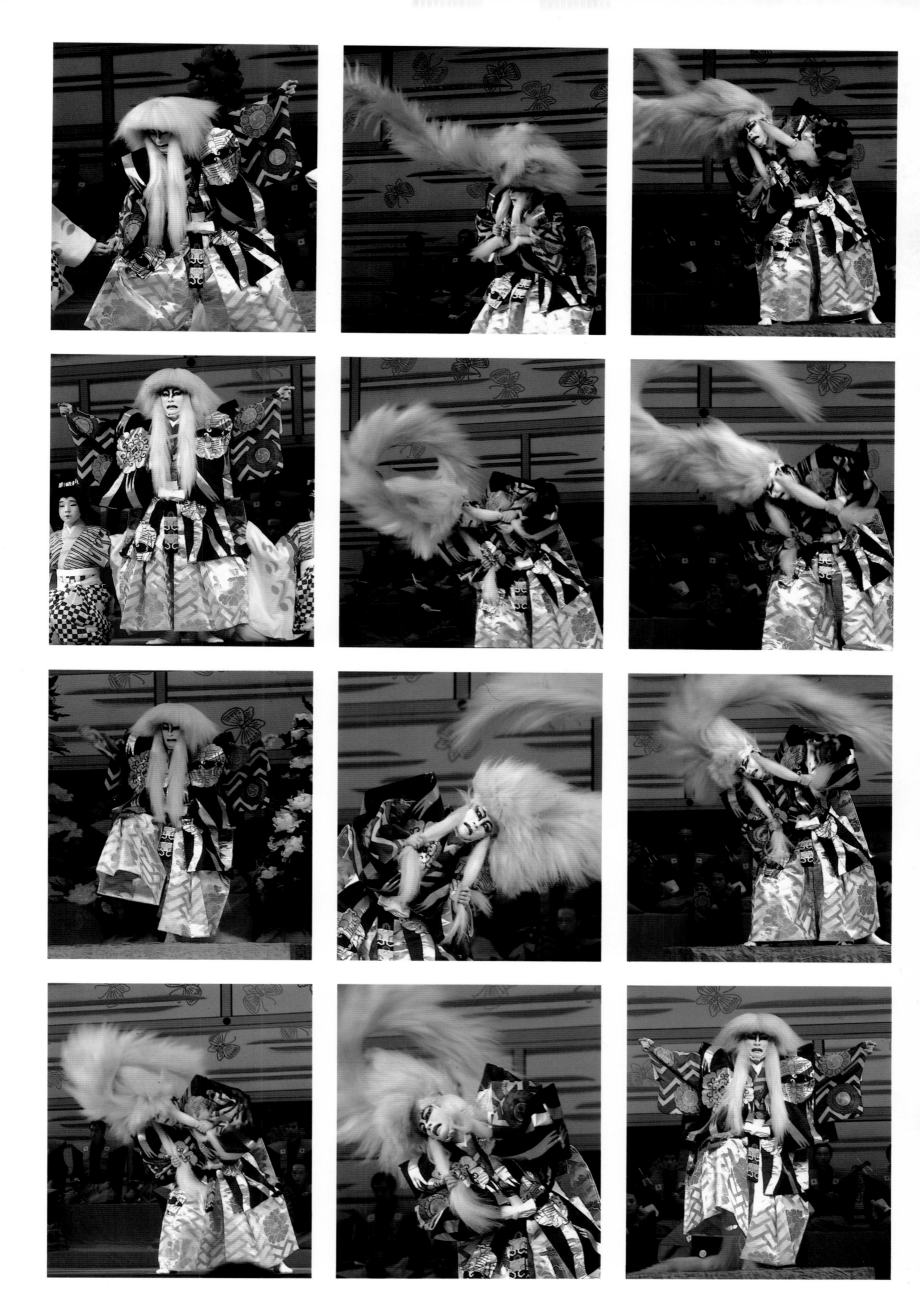

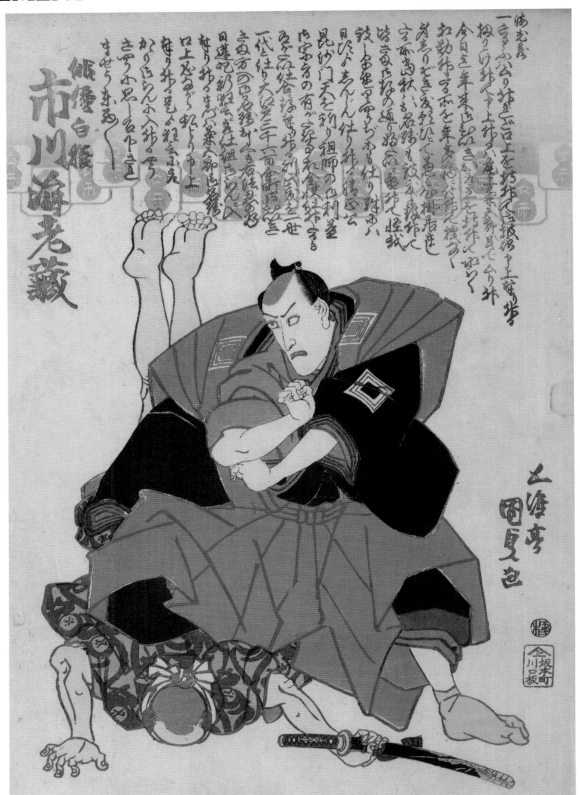

By Utagawa Toyokuni III. Ichikawa Ebizō marks the farewell stage appearance announcement of Onoe Kikugorō III with his bravado style. (National Theater)

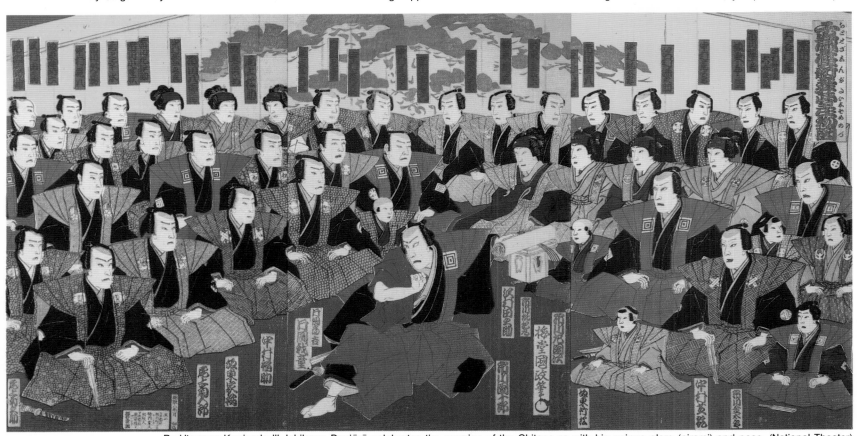

By Utagawa Kunisada III. Ichikawa Danjūrō celebrates the opening of the Chitose-za with his unique glare (nirami) and pose. (National Theater)